Honoring Traditions

Honoring Traditions

MICHIGAN HERITAGE AWARDS, 1985–2004

Yvonne R. Lockwood & Marsha MacDowell

with contributions from

Rebecca Clark, C. Kurt Dewhurst, Ruth D. Fitzgerald,
LuAnne G. Kozma, Laurie K. Sommers, *and* Sarah Stollak

Michigan State University Museum • *East Lansing, Michigan*

ISBN 978-0-944-311-19-9

The *Michigan State University Museum*, founded in 1857, is committed to understanding, interpreting, and respecting natural and cultural diversity. As Michigan's land-grant university museum, this commitment to society is met through education, exhibitions, research, and the building and stewardship of collections that focus on Michigan and its relationship to the Great Lakes and the world beyond. For more information about tours, programs, exhibitions, publications, and the Michigan State University Museum Associates, please call (517) 355-2370.

The *Michigan Traditional Arts Program* at the Michigan State University Museum, in partnership with the Michigan Council for Arts and Cultural Affairs, advances cross-cultural understanding and equity in a diverse society through the documentation, preservation, and presentation of the state's folk arts and folk-life. For more information, please call (517) 355-2370. Learn more at *museum.msu.edu* "statewide programs."

PUBLICATION PROJECT MANAGERS: Lora Helou, Marsha MacDowell
COPY EDITOR: Kathleen V. McKevitt, IDIOM
LAYOUT/DESIGN: Sharp Des!gns, Lansing, Michigan
PRINTING/BINDING: Walsworth Publishing Company, Marcelene, Missouri

Printed in the United States of America

This publication was made possible by grants from Michigan Council for the Arts and Cultural Affairs and the National Endowment for the Arts with in-kind support from Michigan State University Museum and the Michigan State University Extension.

Contents

* Posthumous award

* Posthumous award

MICHIGAN STATE UNIVERSITY
MUSEUM

Twenty Years of Honoring Michigan's Master Artists and Traditional Arts Leaders

The Michigan Heritage Awards Program honors masters of tradition, individuals and groups who, through a long process of observing, practicing, and learning, have become exceptional practitioners of their folk traditions. They become "masters."

Folk traditions are learned as part of the cultural life of a group or community, whose members share language, religion, occupation, geographic region, or ethnic heritage. A central part of group and community identity is its folk traditions, which are shaped by a common world-view, values and aesthetics. Traditions are passed on most commonly within the family and community through oral communication, observation, and practice. While master artists excel at their traditions, they usually are not the only performers of them. Others in their communities often maintain some level of knowledge and skill in the traditions and usually it is the artist's community that encourages and even mentors the perpetuation of the traditions. Therefore, to honor master artists is to honor their communities as well.

Folk traditions are neither frozen copies from the past nor are they unique to the poor and uneducated; rather, they are dynamic, living expressions of everyone's culture, always changing to meet current situations. However, tradition is also conservative, often slow, even resistant, to change. Therefore, the traditions of the masters are both the same and different from that of their predecessors. While faithfully preserving tradi-

tions, masters, inevitably, adapt, adjust and even creatively mold folk traditions to suit circumstances. In this way living traditions remain meaningful to masters and their communities while also making their lives meaningful.

The Michigan Heritage Awardees are diverse, representing many different communities and traditions in the state. Yet it is their relationship to tradition that links them; they share a dedication to tradition and to the cultural values embodied and upheld by tradition. Many of our honored masters have close ties to the traditions of their ancestors and preserve them relatively unchanged. Such is often the case with ethnic artists whose traditions mark the boundaries of their groups and symbolize their identity in a multicultural society. Other masters may have succeeded in preserving traditions while also initiating major changes, such is the case with musicians who tend to be innovators and change musical forms greatly over time. Some masters may have revived a dying or dead tradition because of its deep significance to the group's culture, as with some Native Americans whose traditions were lost as a result of population displacement and forced assimilation. Regardless of the differences, the masters' shared goal has been to maintain high standards of artistic excellence and to preserve cultural tradition that has great meaning to them, their families, and communities. They have pursued these goals through active participation in their traditions and by teaching their skills and knowledge to others in their

communities. They have conserved tradition for future generations and often extend them beyond their own cultures for outsiders to appreciate.

The Michigan Heritage Awards Program was inspired by programs in both Japan and the United States. Japan's "National Living Treasure" program protects traditional cultural knowledge, technique, and the bearers of this knowledge and technique. The living treasures designation means preserving the perfection of techniques along with the belief in the traditional values represented by the created objects. One supports the other. In the United States, as part of its efforts to honor and preserve the diverse cultural heritage of the nation, the National Endowment for the Arts awards master folk and traditional artists with their prestigious National Heritage Fellowships.

The Michigan Heritage Awards program was initiated in 1985 and is coordinated by the Michigan State University Museum as part of its Michigan Traditional Arts Program, a statewide program in partnership with the Michigan Council for the Arts and Cultural Affairs. Through partial support from the Council and the National Endowment for the Arts, this museum program recognizes and praises the learning process that persists through time from person to person, group to group, to maintain folk traditions. It honors individuals who have mastered a folk tradition and continue it with excellence and authenticity and recognizes the extended families, community and tribal elders, neighbors, and friends who, as teachers of cultural heritage, help reinforce traditions. It also acknowledges Michigan's exceptional wealth of folk tradition that greatly enriches the state.

Since its inception, awards have honored masters of material culture and performance as well as individuals who, as community leaders, have promoted, supported, and helped maintain local traditions. Folk expressions that can be touched, so-called material culture, have ranged from textiles to fly tying to barn construction. Performance includes traditional music, song, and storytelling. Community leaders have included a disc jockey, priest, tribal elder, community festival promoter, and regional traditional music supporters. Posthumous awards have recognized individuals who contributed greatly to folklore studies and research in Michigan and who left valuable legacies for those who followed.

The masters of traditions are a living reminder of our rich cultural diversity and that traditional art is homegrown from everyday experience. Although masters often are unknown beyond their communities, it is there they are remembered for generations. Their traditions, however, are treasures for all to appreciate and value. The Michigan Heritage Awards program wishes to expand their realm so that a broader audience will be enriched by their art. With the Michigan Heritage Awards, we recognize and honor the masters of tradition and those who inspired, mentored, and supported them, and we hope their traditions will thrive with each generation.

For more information on the National Heritage Fellowship Program, see *http://www.nea.gov/honors/heritage/*; Steve Siporin, *American Folk Masters: The National Heritage Fellows*, New York: Harry N. Abrams, Inc. in association with the Museum of International Folk Art, Santa Fe, 1992; and Alan N. Govenar, *Masters of Traditional Arts: A Biographical Dictionary*, Santa Barbara: ABC-CLIO, 2002.

Forms and information about nominating an individual or group for a Michigan Heritage Award are available on-line at *www.museum.msu .edu/. . . /mh_awards/mha .html* or by writing to the Michigan Traditional Arts Program, Michigan State University Museum, East Lansing, Michigan 48824-1045.

Honoring Traditions

MICHIGAN HERITAGE AWARDS 1985

Edith Bondie

HUBBARD LAKE / ALPENA COUNTY • BLACK ASH BASKETMAKER

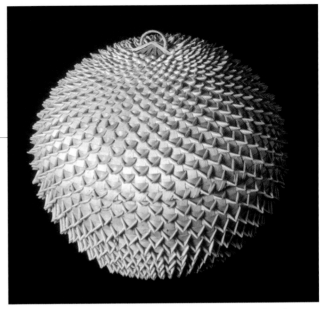

7442. Photo by Pearl Yee Wong.

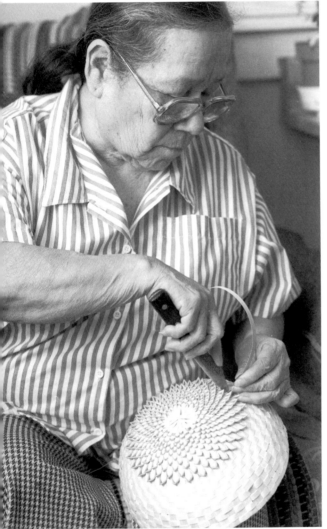

1988:19.9:21. Photo by Al Kamuda.

Born February 14, 1918 in Mikado, the Ojibwa Indian settlement located in a rural area near Oscoda, Edith Bondie's life has always been closely connected to the woods. Her father drove logs down the AuSable River, and her mother was a lumberjack cook who often worked out of a shanty kitchen on a river raft. Edith was raised in Mikado where she learned traditional black ash splint basket-making techniques from her parents and others. "My mom made baskets and she'd throw us kids the scraps. We'd pick them up and play with them and started making baskets on our own. And I've been making them all my life."[1] For many years Edith and her husband, Ward, worked together on baskets. Ward felled black ash trees on their property best suited for baskets, and the two of them took turns pounding the logs and separating the splints. Edith's baskets are known for their thin, smooth, and narrow splints. Aside from the time it takes to gather and prepare the materials, Edith said it took her "up to six weeks, working eight to ten hours a day, to finish one basket."[2]

Although she is adept at making many kinds of utility and decorative baskets, Edith is best known for one basket. She calls it a "porcupine basket" or a "blowfish basket." As she describes it, "You know that ocean fish that blows itself up a lot—the blowfish? It looks like a big balloon with lots of needles all over it. Well, that's what the baskets are supposed to look like."[3]

Edith's work has been featured in many exhibits, including ones at the Jesse Besser Museum, MSU Museum, and, in 1979, as part of the exhibit titled "Craft Multiples" at the Smithsonian Institution's Renwick Gallery. Edith has very generously shared her skills with many others and has been a featured teacher and demonstrator at county fairs, 4-H clubs, Jesse Besser Museum, and MSU Museum.

1. Alan R. Kamuda, *Hands Across Michigan: Tradition Bearers.* Detroit: *Detroit Free Press*, 1993, p. 48.
2. Ibid.
3. Ibid.

Thelma James (1899–1988) was a teacher, collector, and archivist of urban folk traditions.[1] She received her B.A. in 1920 and M.A. in 1923 from the University of Michigan. In 1923 she joined the English department at what later became Wayne State University while taking graduate courses in folklore at the University of Chicago. This same energy sustained her through her long career.

With a colleague, Emily Gardner, Ms. James was involved in the settlement-house movement and conducted folklore-collecting projects with students in Detroit. Concurrently, she supervised other student collectors and archived urban, ethnic, and occupational traditions in the Wayne State University Folklore Archive, one of the first folklore archives in the United States, which she helped establish with Ms. Gardner in 1939. For six decades, this archive had been a valuable resource to scholars and students of Detroit cultures and traditions. In 1999 the Wayne State University Folklore Archive was disassembled and the collections dispersed to the Walter Reuther Archives (Wayne State University), the MSU Museum Archives, and the Great Lakes Lighthouse Keepers Association.

Ms. James was a pioneer in her interest and recognition of the tremendous wealth and diversity in urban traditions, and through her efforts many traditions in Detroit were recorded on Edison wire recordings and preserved. Although she published very little, she devoted considerable energy and intellect to her students and to her profession. Throughout her career, Ms. James also held offices in the American Folklore Society and the Michigan Folklore Society, and she was elected a Fellow of the American Folklore Society. In 1967, after 45 years of teaching, she retired from Wayne State University.

Ms. James's legacy to the residents of Michigan and her colleagues in folklore are her rich folklore collections made in Detroit, collections and publications of her students, and the scholarly endeavors she inspired in those who followed her in the field of folklore study. Upon retirement, she bequeathed funds to the Wayne State University Press to be used in the publication of folklore studies.

Thelma James

DETROIT / WAYNE COUNTY • FOLKLIFE EDUCATOR, COLLECTOR, AND ARCHIVE FOUNDER

1. This entry based on the essay by Janet Langlois, "Thelma Grey James (1899–1988)," in Jan Harold Brunvand, ed. *American Folklore: An Encyclopedia.* Camden: Garland, 1996, p. 403.

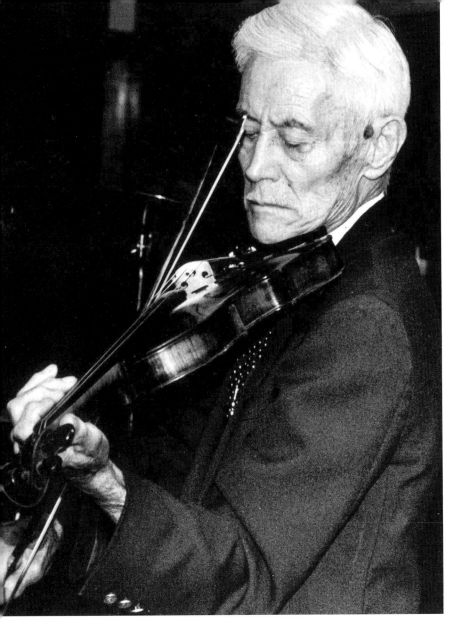

Frank Mattison

SMYRNA / IONIA COUNTY • FIDDLER

rank Mattison (1893–86) and his wife, Irma, like his parents before him, were lifelong traditional musicians and supporters of traditional music. Frank vividly remembered the first time he played. "When I was a kid I lived in a neighborhood where there were fiddlers all around. They used to come to our house and bring their fiddles and dulcimers. That was about 1900. I would just sit and stare and watch their fingers. One night when they were playing cards, I picked up one of their fiddles and started to play. I have been playing ever since."[1]

He played in homes, ballrooms, churches, community centers, and arenas and led a dance band that played in almost every community in the Lower Peninsula. In his eighties, he recorded one tape, "Fiddlin' Michigan Style," accompanied by Irma on saxophone and daughter Francis Geiger on the piano.

Known throughout Ionia County as a music teacher, he estimated he taught fiddle playing to more than 1,000 students and to members of his own family. Granddaughter Karlene Johnson has fond memories of Frank and appreciates her family's passion for music, "I remember when my mother used to take grandfather to the Grand Rapids Symphonette. Soon I started taking him, and I joined the group. The one-and-a-half- hour drive there and back each week gave me the chance to learn about a very fascinating and special person."[2]

Karlene eventually took fiddle lessons from her grandfather, learning some of the many tunes he had mastered in his lifetime. Even into his nineties, Frank was actively playing, sometimes several times a day and performing for others two or three times a week, including with the Senior Neighbors Orchestra at a Grand Rapids senior citizens center.

In Ionia County, the old Otisco Township Hall has been renamed the Mattison Lyceum Hall in honor of the Mattison family and the Lyceum Society headquartered there, which is dedicated to the promotion of traditional music and culture.

1. Manny Cristonomo, "The Fiddler," *The Detroit Free* Press, 23 May 1986.
2. Brenda Conrad, *Ionia Standard,* 3 February 1988.

Art Moilanen

MASS CITY / ONTONAGON COUNTY • FINNISH-AMERICAN ACCORDION PLAYER

Michigan's western Upper Peninsula (UP) is home to the nation's largest concentration of Finnish Americans and is locally referred to as "the sauna belt." Art Moilanen is the dean of Finnish-American piano accordionists in this region.

Born in 1916, Art has lived in Mass City most of his life. He has been a logger and tavern keeper, while all the time playing the accordion. He began to "fool around" with his brother's accordion in 1930 and to imitate what he had been hearing from first-generation Finnish-American farmers and lumberjacks, and he "picked up alotta these Finn songs from a record that we had on an old phonograph at home."[1]

He has been playing ever since. His musical repertoire embraces Finnish-American, country western, and regional dance tunes, reflecting influence of other local ethnic musics, the media, and the UP environment. Two significant influences were Viola Turpeinen, an accordionist and icon in Finnish-American culture, and Frankie Yankovic, "the Polka King." Because of Viola Turpeinen, Art acquired a piano accordion and learned her style and her songs, which he still plays even today. Art also plays "a pretty good polka," some of which he attributes to Frankie Yankovic. One of Art's specialties is parody of pop songs in English. The lyrics are UP or Finnish-American specific and often are about locals; they are expressions of regional values and attitudes or Art's assessment of situations. Art is something of a cultural mediator, communicating both Finnish-American and UP culture values and history to outsiders through the medium of his songs.

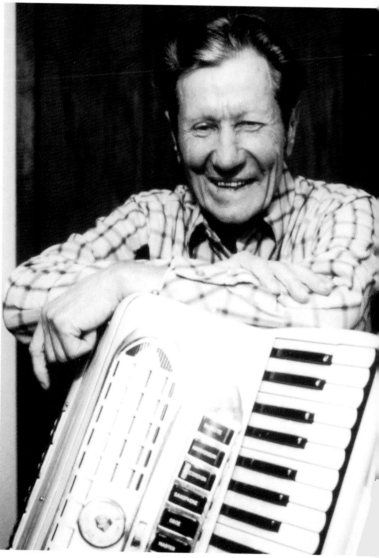

1989:80.4:18. Photo by Al Kamuda.

Art's musicianship has been acknowledged by many. He received Michigan Traditional Arts Apprenticeship awards in 1991 and 1992 to teach piano accordion and Finnish-American music. He has played at music festivals throughout the Great Lakes region and in Finland, for ethnic dances in the region, at local bars, and has participated in music and cultural conservation workshops. In 1987 he participated in the Smithsonian Institute's American Folklife Festival in Washington, D.C., and the Festival of Michigan Folklife in East Lansing. He has been featured on recordings of traditional music of the Upper Peninsula by James Leary and in the film *Tradition Bearers* (1983) by Michael Loukinen. In 1990 Art received the prestigious National Heritage Fellowship from the National Endowment for the Arts. Although retired but still playing, Art says, "After 70 years of music, why quit now!"[2]

1. James Leary, "Reading the 'Newspaper Dress': An Exposé of Art Moilanen's Musical Traditions," in C. Kurt Dewhurst and Yvonne Lockwood, eds. *Michigan Folklife Reader.* East Lansing: Michigan State University Press, 1988, p. 213.
2. Personal communication with Yvonne Lockwood, 2002.

Eli "Little Elk" Thomas

MT. PLEASANT / ISABELLA COUNTY • BLACK ASH BASKETMAKER, DANCE, AND STORYTELLER

From personal collections.
Photo by Pearl Yee Wong.

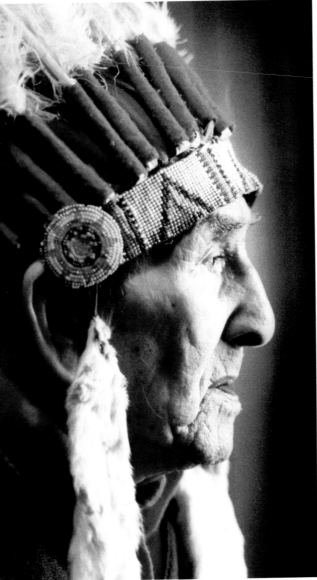

03-1985:47.1:2. Photo by Al Kamuda.

Eli "Little Elk" Thomas (1898-90) was a respected elder of the Saginaw Chippewa Indian Tribe of Michigan. His great-great-grandfather, his great-grandfather, and grandfather were born in Indiantown, a settlement near the town of Saginaw. He remembered a time when the marshes nearby yielded wild rice that he and his family harvested in the fall. Eli was born and raised near Alpena where his parents worked as loggers and, as a teenager, Eli also worked as a logger and a sawyer for several years.

Eli learned basket making by watching his grandparents and parents. From them he learned how to select and harvest the right black ash tree best suited for baskets, pound it "for two or three days" to obtain the strips which are split and shaved into smooth splints, and to prepare the natural dyes that did not fade, unlike the commercial dyes so many weavers now use. He liked to use oak and beech (or alder) to color his splints.

He made all kinds of baskets—laundry, market, bushel, jewelry, hankie, hampers, a coarser type to wash Indian corn in—as well as a basket rattle. He also made strawberry baskets, but he did so with caution. "The strawberry basket is one you don't play around with. The history or story of the strawberry basket is when a person dies who is good, he goes to the happy hunting ground and then half-ways there (it is two days there), he sees a great big strawberry and gets filled up and can go the rest of the way."[1]

Eli, whose parents did not speak English, was proficient in Ojibwa and English. His language skills were important in helping to tell traditional stories, to sing traditional songs, and to officiate at Ojibwa ceremonies as he was often called upon to do. With Don Stevens and Whitney Alberts, he traveled around Michigan and beyond sharing traditional stories, music, and dance at pow wows, schools, and other public venues. The annual pow wow in Mt. Pleasant has been named for him.

1. Interview by Patricia Dyer. 25 October 1988.

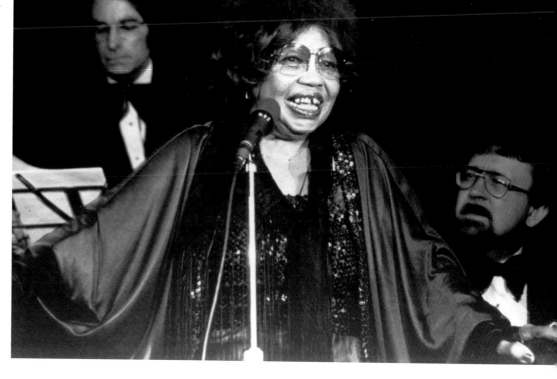

Sippie Wallace

FARMINGTON HILLS / OAKLAND COUNTY • BLUES SINGER

Several major cities of the United States lay claim to legendary blues singer Sippie Wallace, who spent the majority of her adult years in Detroit. Born Beulah Thomas in Houston, Texas, November 1, 1898, she sang and played piano early on in the Baptist church. Sippie's brother, Hersal, played piano and before she was 13 years old they were performing together. In 1915, they moved to New Orleans to pursue music. 1923 was a landmark year for Sippie; along with her brothers, Hersal and George, she moved to Chicago in the midst of a vital, live jazz scene. By the end of the year, her first two singles, "Shorty George" and "Up the Country Blues," on Okeh Records were hits. Sippie wrote many of the 40 songs she recorded between 1923 and 1927, and her powerful musical abilities prompted the record label to bring in respected jazz musicians, such as Louis Armstrong and big band leader King Oliver, for recording sessions.

Sippie almost completely stopped recording and performing publicly after 1936, when her husband, Matt, and brother, George, died. She moved to Detroit, and for the following 30 years, her musical talent and artistry graced the ears and hearts of the members of the Leland Baptist Church in Detroit, where she was the organist and vocalist. In 1966, she released a new album with friend Victoria Spivey, who helped convince Sippie to begin performing again at blues and folk festivals. Bonnie Raitt, who had included several of Sippie's songs on her records, also helped encourage her to emerge again into the blues and jazz scenes. In 1983, Bonnie produced the album *Sippie*, which landed the 85-year-old a Grammy nomination and a W. C. Handy Award for best blues album of the year. In the last years before her death in 1986, Sippie continued to sing, often with the Jim Dapogney Jazz Band, to the delight of her many fans.

1986/7

MICHIGAN HERITAGE AWARDS

Perry Allen

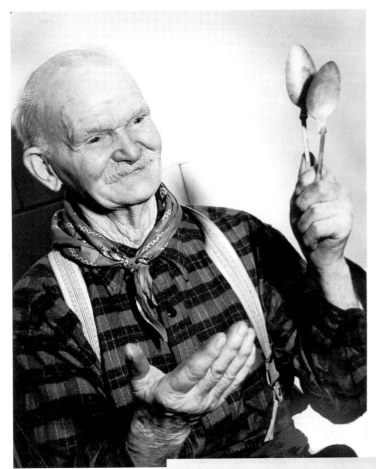

Photo courtesy of Becki Fairman.

1. Unidentified clipping file, courtesy of Beverly Bott, Perry Allen family.

Perhaps the most famous of the Michigan Lumberjacks, a group organized by E. C. Beck, was storyteller, dancer, and musician Perry Allen. Born in Indiana in 1859, Perry moved to Michigan while a child and was a longtime resident of Shepherd. Perry met E.C., who was searching the mid-Michigan area for former lumberjacks to represent the state in the first National Folk Festival in 1934 in St. Louis. In his mid-seventies at the time, Perry was one of the "lively oldsters" chosen for the event.

Following the national debut of the Michigan Lumberjacks at the National Folk Festival, Perry continued performing with the group, traveling throughout the state and nationwide to appear in a wide variety of shows, from radio broadcasts to sportsmen's shows, through the 1940s. His specialties were playing the spoons and tambourine and clog dancing. Perry's songs and stories were also documented by E.C. in his books on Michigan lumberjack lore, including Perry's picture in the frontispiece to *Songs of the Michigan Lumberjack*. Perry was sometimes called "that clever little Michigan Lumberjack" in the media, and he was the subject of the poem "That Little Scotch Lumberjack." His fame brought appreciation from friends and family.

When Perry died at age 88 in 1947, the local paper declared he had "gone to the Shanty Beyond." He was remembered then for "those sparkling eyes, those rattling spoons, that tambourine tapped so fetchingly on his bald head with a fringe of gray, those red and green dancing shoes are now but memories in the minds of many American sportsmen. For that master showman, Perry Allen, will not be forgotten soon by the thousands who were entertained by him."[1]

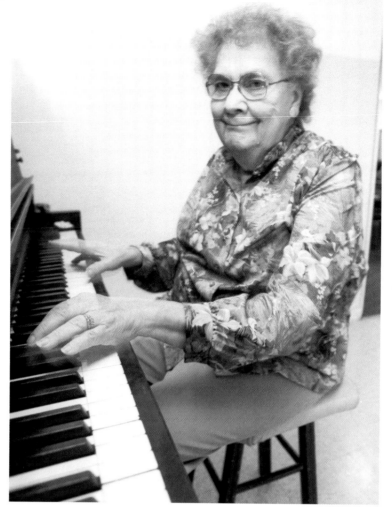

Margarette Ernst, of Harrison and formerly St. Johns, was born April 16, 1915, and died June 23, 1991, at the age of 76. A piano player her whole life, Margarette skillfully and enthusiastically served as accompanist at traditional dances and music events. Although fiddle and guitar players and other instrumentalists receive much of the spotlight and are lauded for their solos, piano players tend more often to go unrecognized and overlooked. Margarette's piano playing was celebrated by her peers, who relied on her tempos and rhythms to provide the background for their performances.

As an advocate of traditional music who maintained and reinforced the traditions of her community, Margarette kept the beat for old-time Michigan round and square dances for 60 years

Margarette Ernst

HARRISON / CLARE COUNTY • PIANO PLAYER

with her precise piano playing. In her later years, she played with the Memory Lane Band for local senior citizen activities and performed at Original Michigan Fiddlers' Association jamborees and dances across the state.

A master piano player recognized by other musicians, Margarette also found recognition by giving back to her community, where she regularly performed for numerous local service organizations. According to the *St. Johns Reminder* community newspaper, "Her piano playing at weekly meetings held by the St. Johns Lions, Rotary and Exchange Clubs contributed a special zest to those groups."[1]

Through her performances, Margarette helped foster and encourage the preservation of old-time music and brought about a greater knowledge and appreciation of this music in Michigan.

1. Obituary. *St. Johns Reminder*. 25 June 1991.

Russell Johnson (b. 1918) is the third generation of a trade that brought his grandfather from Sweden to the woods of Michigan's Upper Peninsula (UP). Perhaps the only blacksmith left in the Upper Peninsula to specialize in making and repairing lumbermen's tools, Russell is widely sought by people whose livelihood depends on good tools. He says the "pulp cutters depend on me."[1]

He is adept at making tools for blacksmithing, logging, and farming—skidding tongs, stove scrapers and pokers, cant hooks, burning irons, punch hammers, log dogs, swamp hooks, walking plows, pickaxes, hatchets, knives, pickeroons, and double-bladed ax heads (or ax-pickeroons). He sells items on order at a local store and at home.

Working in a small, crowded workshop located in the eastern end of the UP, Russell is a spry, talkative man who rarely sits down. Sometimes he works through the night "if some logger wants it for the next day."[2]

He values hard workers and those "who are willing to show up on time."[3]

Russell has taught his skills to son Raymond and grandson Chad, who often work alongside him, pounding the anvil and making the tools the Johnson family has been hammering out for 100 years. Russell helped Chad set up his own small blacksmith shop. He is willing to teach others, saying that the "basic rule is to have no fear of getting your hands black and make sure you love the work and are interested in it."[4]

In recent years he has demonstrated his skills several times a year to local schoolchildren, and he was a participant in the 1987 Smithsonian Institution's Festival of American Folklife in Washington, D.C., and the 1987 Festival of Michigan Folklife in East Lansing.

A man who lives by himself, is at home in the woods, and earns his living making tools for those working with the land, Russell was the featured woodsman in Michael Loukinen's film *Good Man of the Woods* (1987), and Russell now often signs his letters, "Russell Johnson, Logger's Blacksmith and Good Man of the Woods."

Russell Johnson

STRONGS / CHIPPEWA COUNTY • BLACKSMITH

1. Personal communication with Marsha MacDowell. 11 September 1989.
2. Ibid.
3. Ibid.
4. Ibid.

Lawrence "Honey" McCoy

SAULT STE. MARIE / CHIPPEWA COUNTY • PIANO PLAYER

Photo by Al Kamuda.

Lawrence "Honey" McCoy (1904–1988) was one of eight children and lived his entire life at Payment Settlement on Sugar Island located near Sault Ste. Marie and "a stone's throw from Canada." The area's regional and ethnic music influenced the styles and tunes Honey played.

Honey began playing his family's pump organ at age four and performing at house parties around age twelve. House parties were a strong weekend tradition, when workers in the lumber camps would gather with other locals to share and play tunes and dance. "We'd go a long way to go to a dance, often on horseback," Honey commented about the square dances and house parties of his youth.[1]

Fiddle players figured prominently on the traditional music scene, and Honey could always be found backing them up on the organ. Honey recalled that the earliest instruments heard at house parties were the organ and the fiddle, with the guitar and piano introduced later.

Honey was one of the founders of The Sugar Island Boys, an old-time music ensemble dedicated to preserving and performing the regional music they grew up with. This group of traditional musicians mirrored the ethnic diversity of the area, both Canadian and American, calling upon local French, Native American, Scottish, and Irish tunes for their repertoire. Songs such as "Whitefish on the Rapids" or "Devil's Dream" have been local standards for decades. Although dances were called mostly in English, the same songs and dances were called in French, especially across the Garden River in Canada. Other core members of the group included Rene Cote (fiddle), Joe Menard (guitar and vocals), Jack Holt (bass), and Tom Stephenson (dobro).

Throughout his life, Honey played the same local tunes on the piano that he played as a boy, in the same house, accompanied by the dancers, fiddlers, and other musicians he grew up with. According to folklorist Nick Spitzer, "There is no doubt in my mind that on the American side of the border the best old-time ensemble active today is The Sugar Island Boys . . . [Honey] is an essential member to the personality and old-time sound of this group."[2]

1. Interview by Roger Pilon, Sugar Island, Michigan. 24 April 1985.
2. Nick Spitzer. 1987 Festival of American Folklife field report. August 1986.

Cecil McKenzie

1989:19.4.16. Photo by Al Kamuda.

Raised in a family of fiddlers, organists and singers, Cecil McKenzie (1912–1997) grew up in an environment where music was a vital part of her life and house parties were common. Whether sleeping, dancing, or performing, children were a common sight at the house parties where sounds of polkas, squares, schottisches, and step dances filled the air, and this rich musical environment had a profound influence on young Cecil.

Cecil was fascinated as a child by the mechanical pump organ in her home. By the time she was eight or nine years old, she was joining her father at house parties on organ. Cecil was an especially good listener, and, while others played from written music or learned note by note, her gifted ear aided her on Saturday nights at age eleven when she would join the other organists at the silent movies. Another way she learned new tunes was by listening to records on a Victrola. Depending on the difficulty of the tune, she was sometimes able to play a new piece on piano in the course of an afternoon and evening. Her father taught her that learning to play chords was the most important aspect of piano playing, and she grew to be admired for her colorful melodic embellishments and lively tempos.

Since childhood Cecil accompanied traditional fiddlers and was one of the most requested piano players at fiddlers' jamborees and other traditional music gatherings throughout the state. In her later years, she regularly accompanied fiddlers and callers at square dance sessions, and was also active in performing at local nursing homes and senior centers, which was especially meaningful for her. Much of the growth of traditional music activities in the Thumb area of Michigan can be attributed to Cecil's efforts.

Cecil once reflected, "I always had a good time; always liked music. We didn't have other entertainment, and I think that made the difference."[1]

Although she enjoyed playing popular music from the 1920s through the early 1950s, what she liked best were the old fiddle tunes of the British Isles, handed down through the members of her musical family in Michigan and Canada. Cecil is remembered for her tireless commitment toward the continuation and preservation of traditional music, which she approached with joy, energy, and zeal.

1. Steve R. Williams, ed. *House Party: Reminiscences by Traditional Musician and Square Dance Callers in Michigan's Thumb Area*. Port Huron, Michigan: Museum of Arts and History, 1982, p. 21.

Isiah Ross

FLINT / GENESEE COUNTY • BLUES MUSICIAN

Isiah Ross—"Doc Ross"—of Flint, is one of Michigan's most well-known and admired blues musicians. Born in Tunica, Mississippi in 1925, Doc Ross, "The Harmonica Boss," started playing the harmonica when he was six years old and by his teen years was performing in public. His father, a harmonica player, recognized his son's talent at an early age, telling him, "God sends talent. You hit some keys I never heard before."[1]

At age 13, Doc joined The Barber Parker Silver Kings band with Willie Love and shortly after began touring regionally on his own. By the early 1950s, Doc Ross and his Jump & Jive Boys appeared with harmonica legend Sonny Boy Williamson and other blues greats on local radio shows.

Doc Ross recorded songs for many record labels during the late 1940s and early 1950s and cut his first record in 1949, on Chess, called "Dr. Ross Boogie." He then went into the armed service, where he picked up his nickname "Doctor" because of his medical position and also because of his compassion for others. He also learned other instruments so that he could play as a one-man band, simultaneously playing guitar, harmonica, bass drum, and cymbal. Because Doc Ross was left-handed, he learned to play the guitar upside down and backwards, just as he learned the harmonica backwards for the same reason. The idea for forming a one-man band stemmed from both the lack of other musicians in the service and from having seen Joe Hill Louis, a one-man band from Memphis.[2]

Returning from service, Doc Ross recorded "Chicago Breakdown" and other songs for Sun Records. In addition to harmonica, drums, and guitar, he also used instruments such as washboard and broom on his records. However, difficulties with the recording industry in Memphis in the 1950s led him to seek employment in Flint for General Motors where he worked for more than 30 years. Doc Ross continued to play music, touring the United States and Europe and performing at blues concerts and festivals until his death in 1993. According to Doc Ross, "Blues is truth. If it didn't happen to you, it happened to someone else."

1. Alan R. Kamuda, "The Doctor Is In." *The Detroit Free Press*. 7 October 1987.
2. Ibid.

Harriet Shedawin

SAULT STE. MARIE / CHIPPEWA COUNTY • BLACK ASH BASKETMAKER

03-1989:152.21:14. Photo by Al Kamuda.

6664.1. Photo by Pearl Yee Wong.

Harriet Shedawin, a member of the Sault Ste. Marie Tribe of Chippewa Indians, was born in 1917 on Sugar Island, just east of Sault Ste. Marie. She learned basketmaking at an early age from her mother, grandmother, and other elders in her community; it was a necessary skill to make baskets for their own use and to earn money for essentials. "I clothed myself by making [and selling] baskets. We had to do this; it was our survival," she says. Harriet recalls traveling off-island with her family, "We used to come to town and peddle the baskets door-to-door, trade them for food, because we were so poor. I enjoyed selling them for 5 cents."[1]

Throughout her life, until her death in 1989, Harriet continued to make and sell baskets. She also shared her skills with others within her community and the general public. She believed that basketmaking "taught me patience, tolerance, strength, and value in myself." Her husband, Charlie, joined her in gathering and preparing the materials, making the baskets, and selling them at pow wows and local events. She came to realize that basket making is more than a source of income, but also a valued skill. "We don't do it for money, people who do it for money lose the value," she says.[2]

Harriet's nomination for the Michigan Heritage Award was supported by letters from individuals representing a wide sector of Upper Peninsula organizations, from the Indian Health Service in Kincholoe to the Catholic Diocese of Marquette to the Lac Veiux Desert Band of Lake Superior Chippewa Indians. As one person expressed, "Her deep respect for nature and those around her is apparent to all who know her. She teaches these crafts together with traditional values to younger tribal members, as she was taught by her mother and grandmother before her."[3]

Those letters testified to the excellence of her work, her dedication to her craft, and her commitment to teach basketmaking and other aspects of her Ojibwa culture to others.

Harriet's work has been on display at the Jesse Besser Museum and the MSU Museum, and her baskets are prized in countless private collections.

1. Alan R. Kamuda, *Hands Across Michigan: Tradition Bearers.* Detroit: *Detroit Free Press*, 1993, p. 11.
2. Ibid.
3. Joseph Lumsden. Letter of support for nomination of Harriet Shedawin. 5 June 1986.

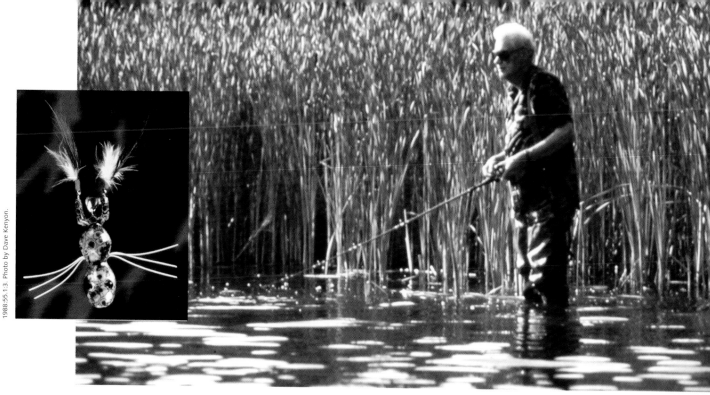

1988:55.1:3. Photo by Dave Kenyon.

1988:55.1:9. Photo by Dave Kenyon.

Elman "Bud" Stewart

ALPENA / ALPENA COUNTY • FISH DECOY CARVER

Fish lure maker Elman "Bud" Stewart (1913–1999) was born in Vancouver, British Columbia, but he lived in Michigan from the age of four when his family moved to Detroit. While living in Flint and Fenton he cultivated his love of a variety of out-door-sports, especially fishing, and it was not long before he was working as a fishing guide.

Disappointed in commercially available lures, Bud began making lures in 1920. He was only 14 when he whittled a crippled mouse lure that proved to attract bass. Other fishers soon wanted copies of the crippled mouse lure, and Bud began a lifetime of inventing and selling lures. He was insistent on creating lures that would be realistic in the water. He claimed to have discarded more than 10,000 shapes in his quest to achieve effective lures. Among his most popular selling lures were the "Pad Hopper," "Bloody Chicken," "Crippled Wiggler," "Muskies," "Horseface," and "Crippled Frog."

By 1933, Bud had established the Bud Stewart Tackle Company. He marketed his lures primarily at sports shows, where he would work up to 13 hours a day talking to customers about his lures. His sales pitches were memorable. A typical spiel was "Goofy things, torpedoes, spinners on front and back—there's no such thing if you look in the lake. There's 100 companies making doorknobs, funny shapes, and broom handles. They put a big eye on it, give it a special name, and you will find some fisherman will buy it. Fish are susceptible at times to strange critters, but we have to refine the bait so the fish cannot see anything artificial."[1]

So successful was Bud's business that he claimed to have sold more than 100,000 of just one design across the country before he retired in 1980. He was named a "legendary angler" in 1984 by the National Fishing Hall of Fame at Hayward, Wisconsin and, in 1987, he participated in the Festival of American Folklife in Washington, D.C., and the Festival of Michigan Folklife in East Lansing.

1. Kenneth L. Peterson, "Bud Stewart: Michigan's Legendary Baitmaker," *Michigan Sportsman*, Vol. 10, No. 3 (April 1985): 16–18; Interview by C. Kurt Dewhurst and Marsha MacDowell, Alpena, Michigan. 7 May 1985.

MICHIGAN HERITAGE AWARDS 1988

02-1987:23.15:7. Photo by Marsha MacDowell.

Donna Esch

FAIRVIEW / OSCODA COUNTY • QUILTER

Donna Esch (b. 1918) remembers being about eight years old when she first started piecing and embroidering, learning from her mother and grandmother. She recalls that growing up in the Mennonite community in the Mio-Fairview region "everybody in the community quilted; all had homemade bedding."[1]

In keeping with another one of the community quilt traditions, Donna's first quilt was made for her hope chest. By the time she married, and thanks to gifts from friends and family, the chest held 16 quilts, including a friendship quilt from relatives in Detroit. Especially satisfying are her memories of "quiltings," wintertime parties that "would start at 9:00 in the morning and go to, but not past, supper."[2]

Since the mid-1960s, one of the biggest annual fundraising activities of this Mennonite community is the annual Relief Sale in August at which scores of quilts made by local quiltmakers are always part of the goods auctioned. From the first year of the Relief Sale, Donna has contributed at least one and sometimes as many as seven quilts a year. On auction day, all of the donated quilts are put on display; Donna's quilts are often the most closely scrutinized and admired. As other quilters have commented, "She uses good [harmonious] colors and her sewing skills are top-notch."[3]

Working year around with other members of Mennonite sewing circles, Donna produces quilts not only for this charity event but also for many others, including Mennonite Relief Sales in other parts of the United States and for Heston College, a Mennonite College in Kansas.

Today, Donna makes quilts not only in the traditional Jacob's Ladder, Grandmother's Flower Garden, and Wedding ring patterns favored by her community, but also has created new designs especially for fundraising purposes. One such design is of Michigan's original 26-star state flag, made in honor of Michigan's sesquicentennial anniversary of statehood.

In addition to being recognized for her quilting mastery within her own community, Donna has received recognition from further afield. Her quilts have been exhibited at the Jesse Besser Museum and Michigan State University Museum.

Photo by Al Kamuda.

1. Interview by C. Kurt Dewhurst. 22 August 1986.
2. Marsha MacDowell. Field notes. 21 June 1980.
3. Ibid.

Edmund White Pigeon

HOPKINS / ALLEGAN COUNTY • BLACK ASH BASKETMAKER

03-1989:20.5:23. Photo by Al Kamuda.

Edmund "Ed" White Pigeon was a descendant of Chief White Pigeon, a Potawatomi leader after whom a town in Michigan is named. Ed was known for producing black ash woven baskets in a great variety of sizes, shapes, and colors. "If you have a basket in mind and can describe it, I can make it," he said. Ed incorporated a variety of weaving patterns in his work, but he was perhaps best known for his use of highly colorful, rainbow patterns.[1]

Ed learned basketmaking from his father and his grandfather at the age of five. He would sit on a blanket next to his grandfather so his teacher could quickly correct any mistakes. His grandfather also taught him how to locate the right tree, to pound the log to separate the growth rings, and to prepare the splints. He recalled that sometimes he looked "at a hundred black ash trees before finding a perfect one." During the Depression, he remembered being able to easily obtain trees from the Gun Lake and Saugatuck areas, but by the 1980s the trees were much more difficult to find. In 1987 he told a reporter, "When I was young, I put in a full day at work, then came home and cut three or four splints for my father, . . . now I do good if I can work all day at one."

His wife, Jennie, is also a talented black ash basketmaker. Together, they passed on their skills to their children, grandchildren, and many other individuals in his community, including youth affiliated with the United Methodist Native American Church. The White Pigeons also demonstrated their skills, not only at local libraries, schools, and civic organizations, but also at statewide events such as the Festival of Michigan Folklife.

Over the years, Ed's work received recognition from both within and outside his community. In 1976, at a local exhibit his community developed as part of the celebration of the United States Bicentennial, his peers awarded a blue ribbon to one of his baskets, an honor for which he was especially proud. In 1987, as a gift to diplomats and officials in other countries, former Michigan Governor James Blanchard commissioned eight of Ed's distinctive baskets. Edmund passed away in July 2002.

7169.1. Photo by Pearl Yee Wong.

1. Personal communication with Pat Dyer. 24 February 1989.

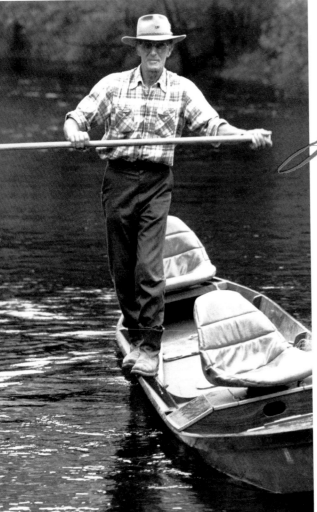

Jay Stephan

GRAYLING/ CRAWFORD COUNTY • AU SABLE RIVER BOAT BUILDER AND GUIDE

Jay Stephan's great-grandfather immigrated to Grayling from Rouen, France. His descendants, like those of many other European immigrants to the region, chose to remain in the Grayling area, where, as Jay puts it, "you can be close to the out-of-doors."[1]

Many of the early immigrants found work in the lumber camps or as hunting or fishing guides along the AuSable River, famed for its natural beauty and its steady supply of trout.

Today the river is still a prime place for trout fishing and the need for fishing guides continues. Jay is considered one of the best by clients and by other guides. He started guiding at age eleven and has guided full- and part-time ever since. He quickly learned how to read the water and become familiar with every bend and twist in the river. In the early years he had to do everything for his client. "You had to teach them how and where to fish," he said.[2]

Because the river is shallow and studded with logs, the most efficient boat used for several generations for fishing has been a long, narrow, flat-bottomed type called the AuSable Riverboat or drift boat. Unlike a canoe that easily tips over, a drift boat is stable enough for a fisher to stand, cast a line, and even reel in a fish. Approximately 20–26 feet long, the boats are designed to drift in the water and are steered by a punt pole. A built-in wet box in the middle ingeniously allows water into a reservoir to keep the catch fresh.

Jay began building riverboats in 1963 at the age of thirty-five when he saw his cousin Norman "Bud" Stephan build and sell them. There were no written plans or drawings. "Bud had everything in his head, just as I do," says Jay.[3]

The original boats were made of pine planks that became heavy when water-sodden, sometimes weighing as much as 400 pounds. By the time Bud and Jay began making them, marine plywood coated with polymers and epoxies was available, which Jay uses today.

Jay has been generous in teaching his fishing and boat-building skills both locally and at special events like the Festival of American Folklife in Washington, D.C., and the Festival of Michigan Folklife in East Lansing.

Photos by Al Kamuda.

1. Interview by C. Kurt Dewhurst and Marsha MacDowell, Grayling, Michigan. 20 August 1986.
2. Ibid.
3. Ibid.

Don "Red Arrow" Stevens

BLANCHARD / ISABELLA COUNTY • OJIBWA CULTURAL TRADITIONS BEARER

Don "Red Arrow" Stevens (b. 1933) is well known throughout the state for his expertise in black ash basketmaking and his skills in traditional Ojibwa dance, storytelling, and song. Many members of his family have made their living making and selling traditional Ojibwa crafts. Red Arrow learned to make black ash splint baskets from his father and grandmother and has been producing baskets ever since he was a young boy. Among his specialties are children's toys fashioned out of small piece of black ash splint; one form he frequently makes is that of a horse.

While he is adept at making many different functional and decorative forms of baskets, Red Arrow is best known for a basket that looks like a strawberry that Red Arrow and other elders call by its Indian name, the heart berry.

Sometimes he sells these, but this basket is more important to him for ceremonial use. "When our young girls used to become the age we considered as adult and responsible for their actions, our village used to give them to the girls. When the girls received this it was a great honor," he says.[1]

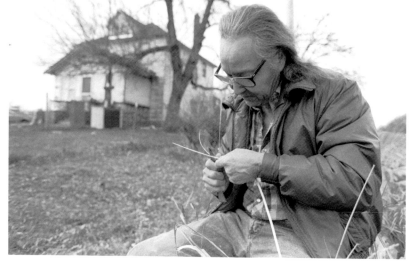

The heart berry basket was also used in naming ceremonies when "the medicine man or lady or the grandparents and parents gave names to the young ones" and a two-inch high basket, called a grave basket, is placed in the grave of the deceased so "they would have the heart berry in the new life. The red color reminds us that the Creator shed his blood for us."[2]

Though he says that some of the members of the community no longer use the strawberry basket for traditional uses, Red Arrow makes sure members know how to make the baskets and use them in ceremonies.

Red Arrow is very dedicated to sharing his traditional skills and knowledge with others in order to increase general understanding of Indian life and, more importantly, to make sure the skill is perpetuated so that baskets will be available for ceremonies in the future.

1. Interview by Lynne Swanson, East Lansing, Michigan. 13 March 1991.
2. Ibid.

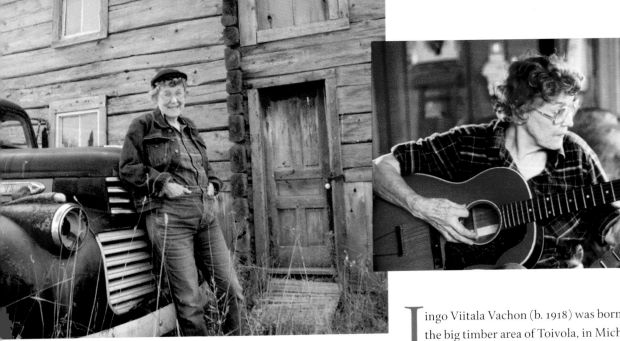

02-1989:80.10:28. Photo by Al Kamuda.

Photo by Al Kamuda.

Jingo Viitala Vachon (b. 1918) was born and raised in the big timber area of Toivola, in Michigan's Upper Peninsula. She has devoted much of her adult life to telling the tall tales, legends, anecdotes, and jokes she heard growing up in this densely populated Finnish-American region referred to as the "sauna belt." Her stories also are portrayals of her personal experiences and life in the Upper Peninsula of her youth.

Jingo is a skilled raconteur. While already recognized locally, she began telling her stories in letters to correspondents, one of whom convinced her to submit her stories to newspapers. She began writing in Finnish and English for publications in Finland and the United States and quickly developed a broad following, especially of Finnish Americans, who appreciated her self-deprecatory humor, which is so much a part of Finnish American culture. Subsequently, *L'Anse Sentinel* (L'Anse, Michigan) published her stories in *Tall Timber Tales* (1973), *Sagas from Sisula* (1975), and *Finnish Fibbles* (1979). She has regaled local audiences and entertained family and friends with her stories and songs.

Although best known as a storyteller, Jingo is also a talented musician. She plays the guitar and sings a very large repertoire of Finnish-American songs in Finnish. She is one of the few remaining second-generation Finnish Americans who knows many songs of the immigrant generation, which she wrote down long ago in a notebook. Her knowledge of this music and song has been a tremendous resource for scholars researching various aspects of the evolution of Finnish-American music. Jingo has also translated American musical standards into Finnish. In addition, Jingo is an accomplished painter. Her paintings have been exhibited in museums, and one of her works is owned by the Migration Institute in Turku, Finland. She also did all the cartoons that illustrate her books on Finnish-American life in Michigan.

Jingo Viitala Vachon

TOIVOLA / HOUGHTON COUNTY • STORYTELLER AND MUSICIAN

In her younger years, Jingo was an avid hunter, fisher, and trapper and she knows her natural environment well. "I tended a coyote trap line that stretched from the back yard nearly to Ontonagon," she once remarked.[1]

Compared to tending this 30-some-mile trap line, Jingo, today, lives quietly just a few miles from her birthplace.

Raconteur, musician, singer, keeper of Finnish-American cultural heritage, Jingo was featured in Michael Loukinen's film *Tradition Bearers* (1983), which documents the life stories of four Finnish-American cultural treasures.

1. Personal communication with Yvonne Lockwood. 2000.

Ivan Walton

POSTHUMOUS AWARDEE, MT. PLEASANT / ISABELLA COUNTY AND BEAVER ISLAND / CHARLEVOIX COUNTY • FOLKLORIST AND EDUCATOR OF GREAT LAKES MARITIME CULTURE

MSUM Ivan Walton Collection.

The legacy left by Ivan Walton is beyond measure. For more than 30 years he researched and collected the songs of Great Lake sailors and documented their way of life and that of their families. "His great enthusiasm for sailor songs and related lore was the impelling force in his work and life," wrote George McEwen, a colleague at the University of Michigan where Ivan taught literature and folklore.[1]

He was honored posthumously for his immeasurable contribution to our understanding of maritime folklore, especially that of the era of the schooner.

Ivan was born in Mt. Pleasant in 1893; he taught at the University of Michigan from 1919 to 1962; he died in Arizona in 1968. As a professor of English he became very interested in the songs of sailors and soon he was spending his summers traveling around the periphery of each of the Great Lakes searching for and interviewing sailors and their families, recording songs,

MSUM Ivan Walton Collection.

and amassing an extensive collection of materials. He returned to Beaver Island year after year pursuing his passion.

His field collections (audiotapes and transcripts, interviews, photos, correspondence, field notes and logs, papers of the Michigan Folklore Society) are preserved in the archives of the Bentley Historical Library, The University of Michigan. Partial copies are also available at the Library of Congress Archive of Folk Culture and the archives of Michigan State University Museum. His collection measures 30+ linear feet, of which the audiotapes are central.

Ivan read papers based on his research at conferences and published some articles; unfortunately, he did not live to finish his manuscript. However, his collections have been made accessible. In the late 1980s, the Bentley Historical Library produced an audiotape with samples of the music he collected. Using Ivan's materials on Beaver Island and supplementing them with her own research, Laurie K. Sommers published *Beaver Island House Party* (Michigan State University Press) in 1996. In 2002, Joe Grimm edited Ivan's collection of songs and published *Windjammers: Songs of the Great Lakes Sailors* (Wayne State University Press) and plans to edit and publish Ivan's journals.

1. George McEwen. "Ivan Walton, A Pioneer Folklorist," *The Michigan Academician* (1970): 73–77.

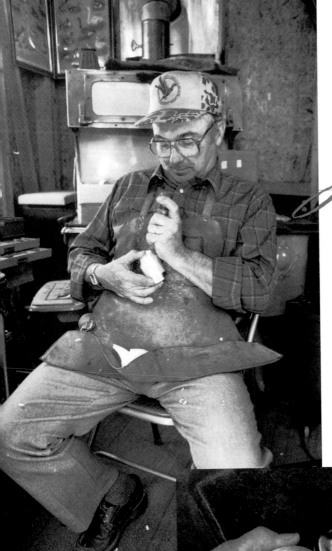

Jim Wicks

McMILLAN / LUCE COUNTY • DUCK DECOY CARVER

Photos by Al Kamuda.

Born in 1932 near Elk Rapids, Michigan, Forrest "Jim" Wicks grew up along Grand Traverse Bay, where he was first introduced to duck hunting. He started carving working decoys when he and his hunting friends became tired of the look of the standard decoy, typically rendered with the bird's head pointing straight ahead. According to Jim, "My first decoys were rough, but good enough to be added to the decoys that my father and I used on Grand Traverse Bay back in the 1940s. Since fashioning those first crude works of art, my interest in decoy carving has expanded greatly. I've carved maybe a thousand of them."[1]

His love of carving is tireless. Jim says, "I hope to die with the chips in my pocket and the knife in my hand."[2]

In 1967 he sent his working decoy to the Midwest Decoy Contest, sponsored by the Michigan Waterfowl Decoy Association and held annually at Pointe Mouillee near Monroe, Michigan. After years of winning awards for his working decoys at the contest, he ceased competing and switched to creating half-life-size birds for ornamental purposes because "the public likes them." He sells about 50 a year. For many years he served as the registrar for the decoy contest, checking in entries and meeting long-time friends and nationally known carvers.

Jim's favorite bird to carve is the Ringneck duck with the Lesser Scaup or Bluebill a close second. One of his trademarks is detail carving on the underside of the duck's bill. Not many people even notice it, but Jim feels this detail makes the duck more authentic and realistic. Jim has taught many, many people how to carve, through informal instruction, formal classes, and as a master artist in the Michigan Traditional Arts Apprenticeship Program.

Duck hunting is strictly a hobby for Jim, who does not shoot as often as he used to because as he said, "We always have duck in the freezer and now we get out there more to enjoy the day and the scenery."[3]

Also an avid ice fisherman, he demonstrated ice fishing as a participant in the 1987 Festival of American Folklife, where thousands of visitors were introduced to an activity rarely known in the nation's capitol.

1. Jim Wicks. "Decoy Delight." *Michigan Natural Resources Magazine*, 1986 (January–February): 36:44.
2. Personal communication with C. Kurt Dewhurst. 1986.
3. Jim Wicks. Cited in Alan R. Kamuda, "Retirement duck soup for UP decoy carver," *The Detroit Free Press*, n.d.

MICHIGAN HERITAGE AWARDS 1989

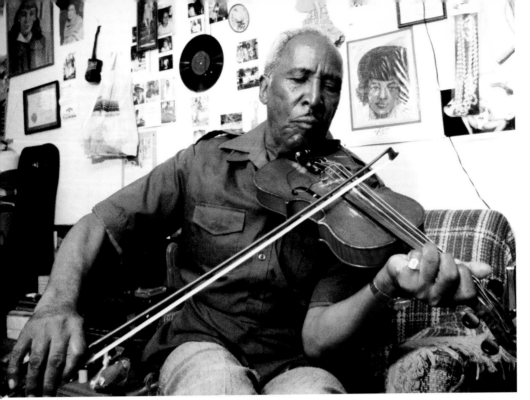

Photo by Al Kamuda.

Howard Armstrong (1910–2003), was one of the last practitioners of the more than 200-year-old Southern string band musical tradition that has been credited with influencing the development of ragtime, jazz, and blues. Southern string bands in the 1920s and 1930s prided themselves on being able to play a wide variety of musical styles, and Howard upheld this tradition. His extraordinary repertoire seemed endless and diverse beyond description and covered the entire spectrum of American music, including traditional "southern" style blues, Tin Pan Alley standards, old-time country ditties, folk songs from nineteenth-century Europe, religious hymns, vaudeville, popular songs, jazz, and Appalachian dance tunes.

The son of a Tennessee miner and part-time preacher, Howard grew up listening to the hymns and spirituals his mother played for him and would practice along with them adding his own blues notes. He formed his first string band while still a teenager. With his partner Carl Martin, Howard played southern coal camps and medicine shows during the 1920s. However, racism in the South prevented groups like Howard's Tennessee Chocolate Drops from participating in string-band competitions or recording studio sessions. In the 1930s, Howard, Carl, his brother L.C., and guitarist Ted Bogan formed a new string band called The Four Keys. They moved to Chicago at the end of the decade, mingling with other blues greats of the era, making several recordings, and occasionally traveling into Michigan to play juke joints and restaurants.

Howard Armstrong

DETROIT / WAYNE COUNTY • BLUES MUSICIAN

After army service in World War II, Howard moved to Detroit and largely gave up performing. In 1972 he reunited with his old partners, Carl and Ted. Until Carl's death, the three performed widely in clubs and on the folk festival circuit. Howard and Ted have continued to play, performing for the Knoxville World's Fair, the Smithsonian Institution's Festival of American Folklife, the Festival of Michigan Folklife, and on State Department–sponsored Goodwill Tours to Latin America. In 1985, Howard's extraordinary life and musical career were documented in the critically acclaimed film *Louie Bluie*, the name under which Howard recorded some of his albums.

Howard's mastery of mandolin, guitar, and the relatively rare blues fiddle gave him a distinction among African-American string band performers. According to Howard, his successful career in music stemmed from his curiosity of the world: "I always had big eyes and big ears, looking for whatever I could see.[1]

1. Joy Hakanson Colby. "Louie Bluie." *The Detroit News*. 23 August 1990: 10F.

Amneh Baraka

DEARBORN / WAYNE COUNTY • PALESTINIAN NEEDLEWORKER

As a young girl, dressmaker Amneh Baraka learned to construct and embroider traditional Palestinian garments from the women of her native village of Beit Hanina. After immigrating to the United States, Amneh continued to make intricately embroidered Palestinian dresses in her new home, Dearborn's South End. Her landlady, Palestinian-born Samiha Abusalah, recalls Amneh, "sitting on her porch embroidering garments" day after day.[1]

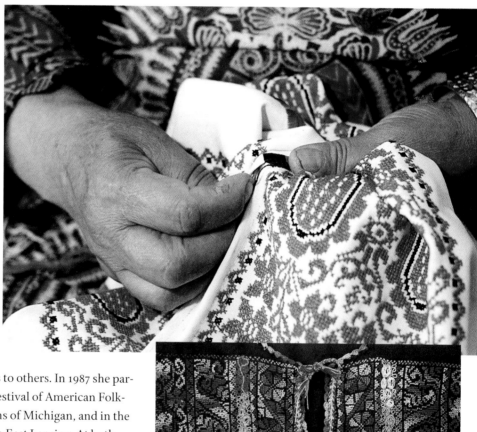

Having come to the United States at a very young age, Samiha had not learned to make traditional dresses and asked Amneh if she would teach her. Always willing to share her knowledge and skills, Amneh taught Samiha traditional Palestinian embroidery.

In 1980 Amneh's reputation as a skilled embroiderer and dressmaker helped the Southeast Dearborn Community Council obtain a National Endowment for the Arts grant for an exhibition and series of classes on Palestinian and Romanian needlework. Amneh was an integral part of these activities, teaching embroidery techniques to others. In 1987 she participate in the Smithsonian Institution's Festival of American Folklife, representing the cultures and traditions of Michigan, and in the first annual Festival of Michigan Folklife in East Lansing. At both events, she was accompanied by Samiha.

Amneh still lives in Dearborn, a city in which Arabs are the single largest ethnic community. Southeast Michigan is home to one of the most diverse, largest Arabic-speaking population outside the Middle East, with some 250,000 people. While more and more women, today, are purchasing their dresses from Palestinian refugees or have machine-couched dresses made for them, Amneh continues to make dresses and embroider designs that she calls "old fashioned" and "ones my aunt back in Beit Hanina taught me."[2]

Photos by Al Kamuda.

Women older than forty still wear these dresses and headdresses adorned with gold coins to weddings, engagement parties, and celebrations of births and graduations. A devout Moslem, Amneh has kept her own traditions and at the same time transcended them to let people outside her community appreciate the artistry of her Palestinian heritage.

1. Personal communication with Yvonne Lockwood. c. 1990.
2. Personal communication with John Allan Cicala. 1987 Festival of American Folklife field notes. 1986.

E.C. Beck

Earl Clifton "E.C." or "Doc" Beck began his lifelong study of northern Michigan lumberjacks in the 1930s. He collected their songs, stories, and dances through the 1940s, urging the 70- and 80-year-old former lumber workers to let him collect and publish the material before it disappeared. Doc taught English and folklore at Central Michigan University, where he also chaired the English department. In addition to his passion for teaching, Doc's love was collecting songs in the woods. He once described his fieldwork as "high adventure," adding that "it has given me unforgettable experiences, vigorous days in the out-of-doors, and some most interesting friends."[1]

03-1991:156.1:3.

The first National Folk Festival in 1934 offered Doc the opportunity to present Michigan lumberjacks and their lore to public audiences. He held a contest for the men to audition, chose just eleven, and accompanied this "lively group of oldsters" as he called them, to sing, dance, and entertain the festival audience in St. Louis. The men dressed their part in boots, red bandanas around their necks, and plaid Mackinaws. They proved to be a popular act. The Michigan Lumberjacks toured both nation and state for the next 20 years under Doc's management, performing for school assemblies, service club meetings, trade shows, local festivals, professional meetings, and radio programs such as *We The People*.[2]

Doc's writings continue to be recognized as significant contributions to Michigan folklore scholarship. His three lumberjack books, *Songs of the Michigan Lumberjacks* (1942), *Lore of the Lumber Camps* (1948), and *They Knew Paul Bunyan* (1956), and his original song sheets constitute a valuable collection of the narrative traditions of an occupational group for which the state is well known. In 1959 the Library of Congress produced the recording *Songs of the Michigan Lumberjacks* for which Doc edited the liner notes. E. C. Beck will long be remembered as the collector of the Michigan lumberjack ballads, for bringing recognition to individual folk artists, and for tirelessly promoting Michigan's logging heritage. He died in 1977 at the age of 85.

1. Earl Clifton Beck. *Songs of Michigan Lumberjacks*. Ann Arbor: University of Michigan Press. 1942.
2. Earl Clifton Beck. *It Was This Way*. Ann Arbor: Cushing-Malloy, Inc. 1963.

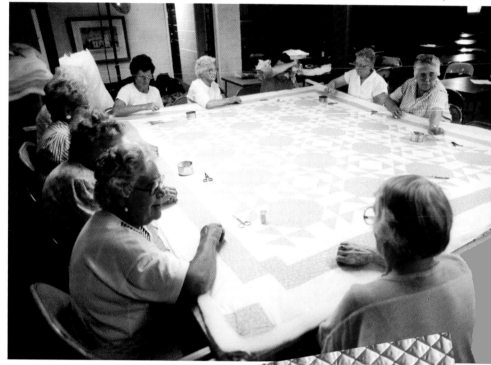

Photo by Al Kamuda.

The Quilters of St. Mary's Church in Lake Leelanau have worked as a group since the 1920s. Both quilting and church participation were long-established practices in the county. Many area quilters gathered neighbors to help them finish their quilts; they often made two identical quilts, donating one to the church and keeping the other for family use. Originally drawn together at these all-day quilting bees, members of The Quilters of St. Mary's Church learned piecing and quilting as young girls from mothers and grandmothers who were among Leelanau County's first white settlers.

Organized as a quilting group around 1928, St. Mary's Quilters initially met weekly in members' homes, later in the Lake Leelanau school, then in the church basement. In the 1950s and 1960s, the group numbered more than 40 active members, and their weekly meetings frequently needed three quilting frames to accommodate all the workers. An average quilting meeting took several hours and included a potluck meal. Occasional card games served as respites from the painstaking, precise needlework, and one member recounted that quiet afternoons of quilting were highlighted when tiny, elderly Martha Plamondon perched on a stool and sang Polish and American songs.

Members of St. Mary's Quilters estimate they have made more than 1,000 quilts for raffles or as door prizes for a variety of parish functions in the last 60 years. Many of their quilts incorporate appliqué designs featuring cherries, the major crop of the region. Although age and the increase in the number of women who need to work outside the home have diminished their number in recent years, the quilters still actively pursue their quilting and provide a source of income for parish and school. Their quilts are well known in the county, and their familiar "Cherry Quilts" are available for sale to the public every spring. Today as in the past, The Quilters of St. Mary's Church concentrate their efforts on producing functional quilts—warm washable bed covers intended for daily use.

1989:58.1. Photo by Keva.

The Quilters of St. Mary's Church

LAKE LEELANAU / LEELANAU COUNTY • QUILTERS

Agnes Rapp

BERRIEN SPRINGS / BERRIEN COUNTY • BLACK ASH BASKETMAKER

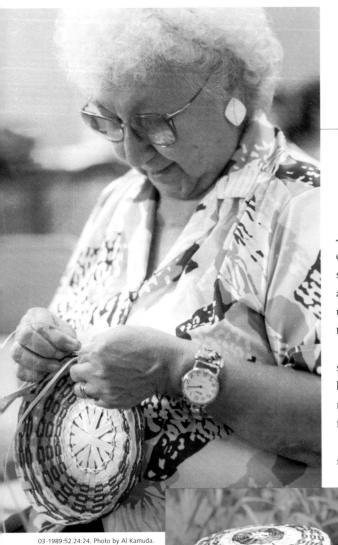

03-1989:52.24:24. Photo by Al Kamuda.

03-1989:52.19:14. Photo by Al Kamuda.

Agnes Rapp (1920–), an enrolled member of the Grand Traverse Chippewa and Odawa Tribe of Indians, learned to weave strips of black ash wood into basket designs from her Odawa stepparents, John and Dela McSawby. "They were into baskets all the time . . . so I grew up with basketry, you know . . . I mean I'd play making baskets although I didn't know how, but I'd pretend I knew how . . . I would cut up the material [black ash splints] on the floor and crisscross 'em and tie 'em up with string and stand 'em up and pretend I'd made a basket."[1]

The family sold their baskets for food money during the Depression. By the time she was ten, Agnes was regularly helping Deliah make baskets and even filling orders on her own. "I got an order for myself to make little round baskets with the handles and when I got those finished the money was mine and I bought a pair of shoes."[2]

In 1939, Agnes married Michael Rapp, a Pokagon Potawatomi from southern Michigan. They first lived in Leland and then, during World War II, moved to southwest Michigan because Michael got a job in a defense plant in Benton Harbor. They both joined a group of Potawatomis who regularly met at a community center in Dowagiac to make baskets. There Agnes taught the traditional skill to the next generation of her family and conducted workshops (often with fellow awardee Julia Wesaw) for both Indian and non-Indian students. Within her immediate family, she taught her daughter, Cindy Muffo, her daughter-in-law, Margaret Rapp, and Margaret's sister, Judy Augusta.

Her baskets are represented in many museum and private collections, including one in China. Agnes's black ash baskets were frequently experimental in style, incorporating new materials and shapes with traditional forms; several recent baskets resemble the flying saucer in *Close Encounters of the Third Kind*.

Agnes appeared in numerous documentary videotapes, been the subject of many news articles and interviews, and was a featured artist in a 1984 exhibition at Western Michigan University. A 1987 participant in both the Smithsonian Institution's Festival of American Folklife and the first Festival of Michigan Folklife, Agnes often demonstrated her craft at art and nature centers, churches, schools, museums, and pow wows.

1. Interview by Laura Quackenbush at the Great Lakes Indian Basket and Boxmakers Gathering, East Lansing, Michigan. August 1997.
2. Ibid.

Julia Wesaw

HARTFORD / VAN BUREN COUNTY • BLACK ASH BASKETMAKER

Julia Wesaw (1908–1992) of Hartford was a Potawatomi who learned traditional black ash basketmaking from her grandmother, Swansee Augusta, and mother, Sarah "Becky" Augusta, who sold baskets to tourists, farmers, and resort residents. Julia made three or four baskets a week, preferring the more traditional forms, such as sewing baskets with lids or market baskets with sturdy handles. Julia's talents were many; in addition to making black ash baskets, she crocheted, quilted, and did traditional beadwork. She transmitted her skills and knowledge to several generations of her family, including her granddaughters Tammy and Loretta Wesaw and great-granddaughter Ginny.

In the mid-1950s, basketmaking within the Dowagiac community declined but was revived in the mid-1970s when Philip Alexis, Pokagon Potawatomi tribal chairperson, asked elders if they remembered how to make baskets. Julia replied, "Well, we can still make baskets but we can't find the wood." Philip came back 20 minutes later with a black ash tree and later reported "they've been making baskets ever since."[1]

At first, the elders formed a small co-op, which later became the Potawatomi Basketmakers Exchange. The men gathered and pounded the wood and made the handles and ribbings; the women prepared and wove the splints into baskets.

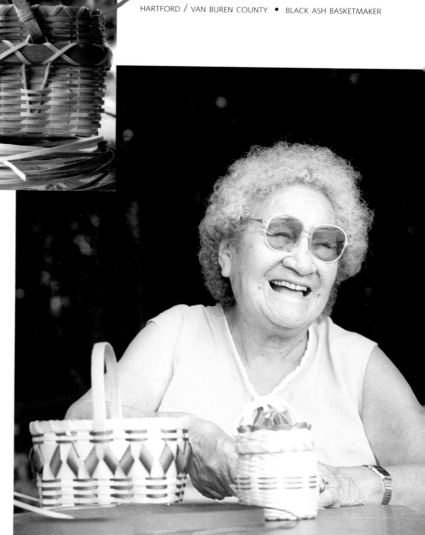

03-1989:52.33:10a. Photo by Al Kamuda.

Like fellow black ash basketry cooperative member Agnes Rapp, a frequent partner for demonstration and teaching sessions, Julia was a dynamic catalyst for the continuation of basketmaking and other traditional arts, including ribbonwork, leatherwork, beadwork, and quillwork. They also were instrumental in reinvigorating the sweat lodge and spiritual meetings.

Julia participated in the 1987 Smithsonian and Michigan Festivals, was a featured artist in the 1984 Western Michigan University basketry exhibition and was the subject of a number of interviews, documentary videotape presentations, and news features. Baskets by Julia and fellow basketmaker Agnes Rapp were featured in an article in *American Indian Basketry* magazine and in the publication *The People of the Three Fires (1986)*.

1. Rita Kohn and W. Lynwood Montell, *Always a People: Oral Histories of Contemporary Woodland Indians.* Bloomington: Indiana University Press,1996, p. 30.

MICHIGAN HERITAGE AWARDS 1990

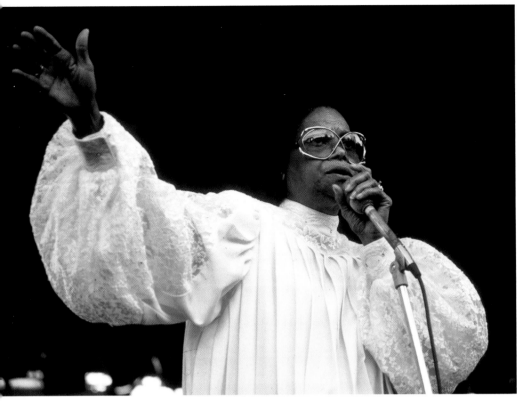

02-1990:53.7:6. Photo by David Perry.

During a career that spanned over a lifetime of 69 years, Dr. Mattie Moss Clark (1925–1994) composed and directed gospel songs that have become classics. At least three of her thousands of compositions are certified as "gold": "Climbing Up the Mountain," "Wonderful, Wonderful," and "Salvation Is Free." As international minister of music for the Church of God in Christ, she was among the last of a generation of musicians, directors, arrangers, and composers who made Detroit a center for the mass choir sound and for African-American gospel music in general.

Dr. Clark wrote her first composition in 1958 and continued composing, arranging and directing choirs for Detroit's Bailey Cathedral Church of God in Christ. She was one of the organizers of the Southwest Michigan Church of God in Christ State Choir, the first African-American gospel choir to record on Kapp Records. Dr. Clark recorded and/or produced more than thirty albums, which have attracted some of the most talented young singers and musicians in the country.

A Selma, Alabama native, Clark grew up in a musical family that included an evangelist mother and nine sisters and brothers, all of whom are musicians. Throughout her youth she spent more than twelve years studying music, privately and at Selma University, but her grounding in the traditional gospel sound and her focus on biblically based texts remained paramount. A traditionalist at heart, Mattie was not afraid to change with the times; her willingness to incorporate newer elements within the context of traditional gospel was responsible for her continuing influence over younger musicians. Dedicated to education, she founded the Mattie Moss Clark Conservatory of Music in Detroit to further the talents of vocal musicians as well as instrumentalists on organ and piano, percussion, woodwinds, and strings. The conservatory's emphasis reinforces her belief that gospel is not only the word of God set to music but an art form deserving of greater respect and recognition from the community.

Through her recordings, her nationally and internationally recognized compositions, and her mentorship of numerous prominent gospel performers and directors, she secured a lasting and influential place in the history of African-American gospel music in Detroit and the nation.

Mattie Moss Clark

DETROIT / WAYNE COUNTY • GOSPEL SINGER, COMPOSER, AND DIRECTOR

Dave Kober

MCBAIN / MISSAUKEE COUNTY • ICE-FISHING DECOY CARVER

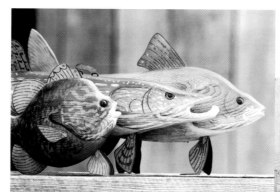

Photos by Al Kamuda.

Ice fishing is a well-established activity in Michigan. Dave Kober represents one of four generations of his family's passion for fishing and for making distinctive ice-fishing decoys. Born in 1938, Dave was introduced to ice fishing by his grandfather, Lester Ballard, and by his uncle, Myron Ballard. His memories of his grandfather and ice fishing are strong: "Whenever I pick up a piece of wood or set out across a frozen lake, I can't help but remember him."[1]

"Uncle Mike" nurtured Dave's carving by giving him his first equipment; Dave was nine years old when he made his first decoy. Both men were instrumental not only in showing him the finer points of fishing and carving but in passing along many family fishing stories.

Ice-fishing decoys vary dramatically in appearance, use of materials, and theory. Dave has developed a visual style that utilizes the natural grain of the wood to replicate the look of the fish. He applies acrylic paint over the grain of the wood and then sands and waxes the decoys, which allows the wood grain to show through the paint. In addition to this technique, Dave developed a tradition of creating decoys that position the carved fins so the decoy "stands" on these fins when out of the water. Whereas most carvers choose not to place the fins below the fish in the natural position, Dave insists on this practice.

Dave took an early retirement as a construction foreman to do what he likes best: make decoys. Dave's decoy making has become a full-time business known as The Wooden Fish. He makes 45 species of inland fish, carving a total of about 250 a year. Dave now sells his decoys at wildlife art shows around the country and was even twice featured on the HGTV network. His decoys can be found in numerous public and private collections around the world.

Like his grandfather and uncle, Dave also loves to share his carvings and his stories with others. He takes special pride in the fact that his son, Travis, also makes fish decoys and ice-fishing jig-sticks.

1. Dave Kober Decoys. *http://www .koberdecoys.com/koberfamily .html*. 30 June 2002.

Sonia "Sonnie" Maria Perez

LIVONIA / WAYNE COUNTY • PIÑATA MAKER

Photos by Al Kamuda.

1. Based on field notes and nominations by Laurie Sommers.

Sonia "Sonnie" Maria Perez, the "*piñata* lady" of Livonia, is recognized within the Detroit community for her exceptional artistry, skill, and humor. Born of Mexican parents in 1918, she and her family came to Detroit in 1922 and settled in the southwest Detroit Mexican community near the Ambassador Bridge and St. Anne's Catholic Church. Although she did not begin making *piñatas* until she had children of her own, she inherited the considerable artistic skills of her mother, who made paper flowers for the church altar and was renowned for her *nacimientos*, or elaborate Christmas crèches.

Although many people make *piñatas* for family birthday parties and other festive events, few achieve Sonnie's creativity and care for detail. She began with simple round shapes and the traditional *estrella*, or star. Over the years, however, she experimented with additional balloon shells and paper-towel tubing to create her own distinctive papier-mâché sculptures. She fashions figures such as Santa, snowmen, leprechauns, raisins, Miss Piggy, Darth Vader, doves, *charros*, and clowns, many with her trademark eyes and curly lashes. While most people decorate *piñatas* with curled paper "fiesta strips," Sonnie also uses paints, especially to create smooth and realistic faces for her figures. Sonnie has made *piñatas* for her family and for various community events, but most of her customers are non-Latinos. She has made her skills available to the community-at-large by teaching *piñata*-making, including workshops for the Detroit Children's Museum and the Girl Scouts in southwest Detroit.

Sonnie is also a community activist. In addition to her *piñata*-making activities, she and her husband have been active in promoting Mexican heritage for more than 50 years. Her first *piñata*, in fact, was for a party of the Mexican-American World War II Veterans Post 505 of the American Legion; her fundraising activities also were instrumental in the founding of the post. In 1952 she instigated what may have been Michigan's first Mexican pageant, as well as the Mexican-American Auxiliary to Post 505. She also has a well-known collection of papier-mâché dolls that chronicles the history of Mexico. This doll collection has been used as part of numerous presentations of Mexican history to community groups and school children.[1]

MICHIGAN HERITAGE AWARDS 1991

Capt. Edward Baganz

GROSSE POINTE PARK / WAYNE COUNTY • GREAT LAKES FREIGHTER CAPTAIN AND TELLER OF SEA STORIES

Edward C. Baganz was born in Berlin, Germany, in 1900 and immigrated as a young child with his parents to the United States, settling in Detroit. In his teens, while apprenticing with a Detroit architect, he was literally shanghaied aboard the *Owana*, a side-wheeler on the Detroit River, by a "brass button guy" who tricked him by saying "the captain wants to see you."[1]

Before he knew it, the *Owana* was under way bound for Port Huron, and Capt. Baganz was handed an apron by the cook who said, "Glad you're going to help us out." This unusual adventure convinced Capt. Baganz that a seaman's life was for him.

Over the decades, Capt. Baganz rose in rank from deckhand to captain. His first command was the *Zenith City* in 1940. He then commanded various vessels in the Pittsburgh (U.S. Steel) Steamship Company fleet, eventually becoming one of only four commodores of what was then the largest steamship fleet on the Great Lakes. Captain Baganz retired in 1966, after serving on the lakes for 51 years. Like most captains, he led a life of eight months a year at sea, crisscrossing the Lakes many times. While on land, he lived in Grosse Pointe Park and was active in the International Ship Masters Association. During retirement he frequently traveled the Great Lakes, visiting maritime museums, friends, and maritime events.

Captain Baganz was highly regarded by his fellow seamen and especially known for his skill in telling sea stories of his life and experiences on the Lakes. One of his favorites was a story he would always end by saying it was "the time a ship saved a lighthouse and a lighthouse saved a ship," about a particularly rough storm in 1940 while captain of the freighter *Perkins*, which had a close encounter with the Lansing Shoal lighthouse in Lake Michigan. In retirement, he traveled extensively around the Great Lakes on land and by water with fellow retired mariners, often stopping in at maritime events in his dark blue uniform, always willing to share his stories. He would return to his home on Harsen's Island where he could view the passing freighters and exchange a greeting. He participated in the 1990 and 1991 Festivals of Michigan Folklife. Capt. Baganz passed away in 1996.

1. Interview by LuAnne Kozma, Harsens Island. 1985.

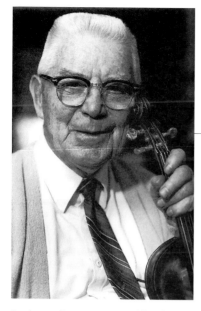

Les Raber

HASTINGS / BARRY COUNTY • FIDDLER

Leslie Raber (1911–99) grew up in Allegan County, in a family of traditional musicians. His grandfather, a fiddler, and grandmother, an organist, were well-known and active dance musicians. Les's father was also a musician, as were all his siblings, but Les was the only one in the family who followed his grandfather's footsteps and mastered the fiddle. Les's mother encouraged his fiddle career by fashioning makeshift instruments from a corn stalk and cigar box, and finally bought him a violin from Sears Roebuck when he was ten years old. By age fifteen Les was playing for hall dance parties, performing a repertoire he learned at house parties from his grandfather and other local musicians. These older quadrilles, waltzes, jigs, reels, schottisches, and two-steps remained an integral part of Les's repertoire, preserving a fiddle style common to rural Michigan before the world wars and the introduction of Appalachia styles: rhythmic and straightforward, emphasizing clear communication of dance melody rather than fancy bowing and ornamentation.

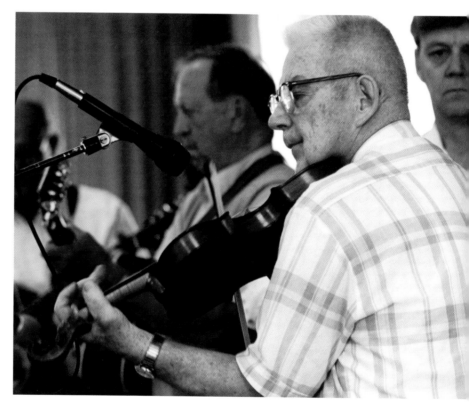

Photos by Al Kamuda.

Les remained an active musician throughout his adult life and played for dances in local granges and lodge halls in southwestern Michigan. For nineteen years he had a dance band with longtime friend and fellow fiddler Varsal Fales. For Les, who worked a poor farm in hard times, the band revenue often put food on the table. Over the years, Les adapted to changes in the local dance and music traditions by continuing to expand his repertoire and learning to play drums for the modern dance bands popular in lakeside pavilions after World War I. Even through this period of great change, however, when foxtrots largely eclipsed the older square dances, Les maintained the earlier repertoire of fiddle tunes. He was one of the few traditional performers of dances once common in Michigan communities, such as "Docey Balinette," "The Basket Dance," "The Irish Trot," and "Sally Waters."

Les continued to perform at jamborees, wedding anniversaries, senior citizens events, and festivals until his death in 1999. In 1987 he was part of the Michigan program at the Smithsonian Festival of American Folklife.

MICHIGAN HERITAGE AWARDS 1992

Yvonne Walker Keshick

Yvonne Walker Keshick has the distinction of being one of the finest quillwork artists in North America. Born in 1946 in Charlevoix, one of five children of Levi and Josephine Walker, Keshick is the descendent of a long line of excellent quillworkers. Her grandmother, Mary Ann Kiogima, was reputedly one of the finest quillworkers of the early twentieth century. Yvonne began making porcupine quill boxes in 1968 with her aunt, Irene Walker, and teacher Susan Kiogima Shagonaby. By 1980, after spending nearly two years working alongside Susan and learning many of Susan's designs, Yvonne decided to do quillwork full time for the rest of her life.

Historically, porcupine quill designs were passed from one generation to the next. Families sometimes owned the rights to certain designs. The quill-workers in her family are known for creating quilled designs of wildlife with exquisite realism. Their animals seem to bristle with life; their floral designs reflect the intricate delicacy of the plants themselves. Yvonne learned many of Susan's designs and also draws upon nature for her own motifs. For instance, she is known to design boxes with fish at the start of trout season or lightning bolts after a severe rainstorm.

Especially knowledgeable in the stories and traditions associated with quillwork, Yvonne tells the story of how a bear learned the hard way to avoid porcupines: "When the bear reached out to touch the porcupine, it pulled its paw back quickly, finding it full of quills."[1]

Yvonne now finds it appropriate to use quills to depict bears on her birch-bark boxes.

Yvonne generously shares her skills with her community and family, including her husband John, sons Arnold and Jacob, and daughter Odemin. To ensure the continuation of the tradition, she has written a manuscript that provides instructions on making quillwork, as well as information on the cultural meanings related to quillwork. Yvonne is honored as a dominant and respected force in preserving quillwork and other aspects of the cultural heritage of the Little Traverse Bay Band of Odawa.

Photo by Doug Elbinger.

02-1994:81.55. Photo by Doug Elbinger.

1. Marsha MacDowell, ed. *Gatherings: Great Lakes Native Basket and Box Makers*. East Lansing: Michigan State University Museum with Nokomis Learning Center, 1999, p. 28.

Daniel Rapelje

LANSING / INGHAM COUNTY • PIGEON BREEDER, TRAINER, AND FLYER

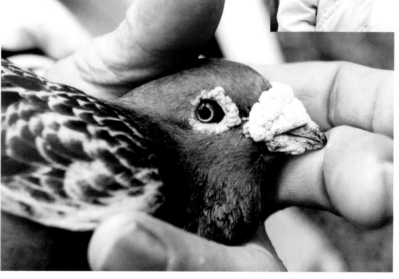

Photos by Al Kamuda.

The sport of racing pigeons is popular in Michigan with more than 400 "flyers" statewide organized into local clubs and regional groups called "combines." Pigeon racing requires expertise in raising the birds, knowing how to breed them, and training them to become good homing pigeons for races. "Old Bird" and "Young Bird" races take place in the spring and summer when clubs and combines release the birds from a location 100 to 500 miles away. Flyers wait at their lofts for the birds to return, at which point the flyer "clocks" the birds by removing special race bands called "race rubbers" and inserting them in the racing clock. Winners are determined at the local clubhouse where the clock results are tallied by the club secretary. Distances in air miles between each flyer's loft and the race starting point are carefully calculated to ensure accuracy.

Daniel Rapelje (b. 1935) is a respected pigeon flyer in Michigan. He took up the sport in 1980 following his father's death when he inherited his father's pigeon loft, equipment, and birds. Daniel learned the tradition from his father when he was a boy and quickly became immersed in the sport. Now he has nearly 250 birds that he affectionately calls his "kids."[1]

Daniel flies pigeons in four different mid-Michigan clubs: the Heart of Michigan Pigeon Club; the Lansing, Michigan Pigeon Club; the State 500 Pigeon Club; and the Central Michigan Combine. He also belongs to the American Racing Pigeon Union. He served as president of the Heart of Michigan Club and the State 500 Pigeon Club and as secretary-treasurer of the Central Michigan Combine. He goes out of his way to teach the tradition to young people at events such as the 4-H Pigeon Show. School groups often visit his backyard loft.

Daniel demonstrated this traditional sport at the 1988 Festival of Michigan Folklife by holding races of small numbers of pigeons, allowing visitors to make predictions on which bird would win the race, then releasing the pigeons on the festival site.

1. Interview by LuAnne Kozma. 1987.

Aaron "Little Sonny" Willis

DETROIT / WAYNE COUNTY • BLUES HARMONICA MUSICIAN

Detroit has been an important regional blues center since at least the late 1920s. Among the many prominent African-American blues musicians working in Detroit, one of the most respected by fellow musicians, is Aaron "Little Sonny" Willis, "King of the Blues Harmonica." A prominent composer and arranger who has written more than 100 songs, he is perhaps best known for the hot, hard-driving harmonica sound that has made his home an international mecca for those interested in blues. Many view him as heir to the great blues harp player Sonnie Boy Williamson, from whom he derives his nickname, "Little Sonny."

Photo by Al Kamuda.

Little Sonny (b. 1932) grew up in Greensboro, Alabama, where he sang gospel and spirituals. After his mother gave him a toy harmonica, he increasingly listened to country and western and blues harmonica on the radio, as well as recordings of famous blues performers. He moved to Detroit permanently in 1953 when the legendary blues scene on Hastings Street was reaching its peak. Beginning in the mid-1950s, Little Sonny held house band engagements at Detroit blues clubs for twenty years, employing many prominent bluesmen. He made his second recording, *Love Shock*, in the back room of Joe's Record Shop (later the JVB label), which was re-released and distributed nationally by Excello.

During the late 1960s and early 1970s Little Sonny toured nationally and recorded three albums with the Stax subsidiary, Enterprise. His original blues and R & B songs have been released on albums by such artists as Albert King and Bobby Womack. A true appreciation of Little Sonny's artistry, however, can only be obtained in person. He is a consummate entertainer, moving and playing on stage with incredible intensity and energy. He continues to tour internationally, and currently has a five-member band called Little Sonny and the Detroit Rhythm Group.

Little Sonny has been a mentor to many musicians, not the least of whom are his talented sons, Anthony and Aaron, Jr. His message is this: "You must know who you are before you can find any other direction. Blues is the roots of you. Blues, jazz, spirituals, this is you."[1]

1. "Little Sonny Willis," Festival of Iowa Folklife 2001, Global Sounds Artists. 25 June 2004.

MICHIGAN HERITAGE AWARDS

1993

Jewell Francis Gillespie

BEAVER ISLAND / CHARLEVOIX COUNTY • IRISH MUSICIAN

Jewell Gillespie (1917–95) occupies a unique place within Beaver Island tradition, having brought together the older generation of Irish musicians he knew as a youth and a younger generation, that includes his children, Danny and Cindy, his son-in-law, Edward Palmer, and his nephew, Barry Pischner, who carry island music in new directions. Jewell sang at many house parties and often was a lead instrumentalist. He is best known as an accompanist, though, and he played a key role in the island's musical culture.

Jewell grew up with the lilting jig tunes and ballad singing brought by the Irish who settled Beaver Island beginning in the mid-nineteenth century. Over the years he taught himself ocarina, mouth organ, piano, and fiddle. With a keen ear and appreciation for music, Jewell performed for neighbors since his teens, and the Gillespie home was the site of many house parties. He knew many of the old Irish tunes, but his interests and repertoire changed with the times, influenced by Tin Pan Alley, country western, and IRA songs that he learned and taught to his daughter, Cindy. Jewell also composed several well-known Beaver Island songs such as "The Town of St. James" (inspired by the Burl Ives song, "The Town of Calrain"), "Enoch Hill" (based on a bootlegging incident on Beaver Island), and the jig tune, "On the Beach at Beaver Island," which has become the signature tune for island parties.

Jewell's contribution is significant not only because of his sustaining role in his own community, but also because of the national recognition accorded the island through the mid-twentieth century field recordings of collectors Ivan Walton and Alan Lomax, housed at the University of Michigan Bentley Library, Library of Congress, and the MSU Museum Archives and Collections. These recordings, in which Jewell is featured as the back-up guitarist for the late island fiddler, Patrick Bonner, document the island's Irish music retention and are a testament to its remarkably rich musical heritage. Jewell Gillespie served as performer, composer, and teacher of Beaver Island music, and the Michigan Heritage Award honors his long musical career and the island tradition that he helped to shape.[1]

Photos by Al Kamuda.

1. Materials drawn from reports and nominatons of Laurie Sommers.

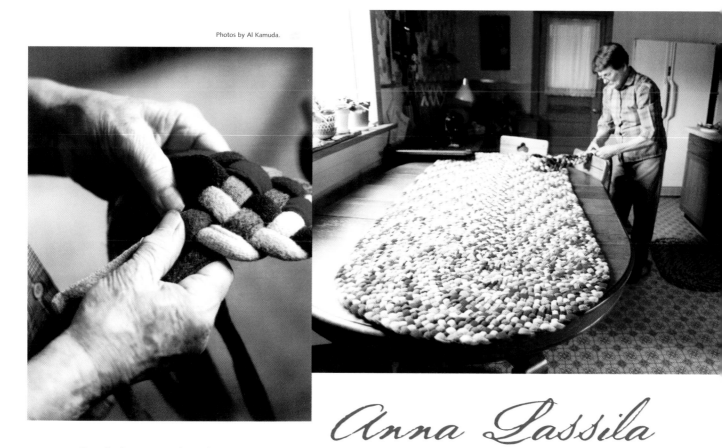

Photos by Al Kamuda.

Anna Lassila

MOHAWK / KEWEENAW COUNTY • FINNISH-AMERICAN TRADITION BEARER

Anna Lassila (1909–2001) was born near Mass City to parents from western Finland. She grew up on the family farm, learning skills that nurtured her throughout her long life. Of her many skills, Anna is best known for her rag-rug weaving. Many years after she married, she acquired a loom and returned to weaving, a skill she learned when she was 13 years old. Although praised for her woven rugs, recognition of great skill also comes with her superb five- and seven-strand braided rugs.

Anna's home was a showcase of textile tradition. Walls, floors, furniture, and beds were graced with textiles by Anna: intricately patterned woven wall hangings; woven and braided rugs; upholstered furniture; crocheted afghans, doilies, and bedspreads; woolen bed throws still reminiscent of the coats they once were; quilts, tied and quilted. Much of her materials were recycled and reused for Anna was the consummate recycler. "I like to make things out of nothing. Anybody can buy [fabric] and make something, but when you make something out of what people have discarded, it can be a treasure."[1]

Looms, like furniture, were prominently in view, communicating the importance of weaving in her life. Anna's skills extended to traditional Finnish foodways, knitting, sewing, tailoring, and even woodworking. She learned within her family, from neighbors, co-ethnics, and co-residents of the area. Some skills she learned out of necessity, some out of desire.

Teaching others was always important to Anna. She unselfishly received young girls who want to learn Finnish-American cookery, and for decades she assisted weavers. In 1987 she was an invited participant at the Smithsonian Institute's Festival of American Folklife in Washington, D.C., and at the Festival of Michigan Folklife in East Lansing. In 1990 and 1994 she was awarded Michigan Traditional Arts Apprenticeships to teach multiple-strand rag-rug braiding and rag-rug weaving, respectively, to Lorri Oikarinen of Calumet. Anna's expertise and traditional knowledge gained through decades of activity are greatly respected and honored.

1. Interview by Yvonne Lockwood, Mohawk, Michigan. 1986.

MICHIGAN HERITAGE AWARDS 1994

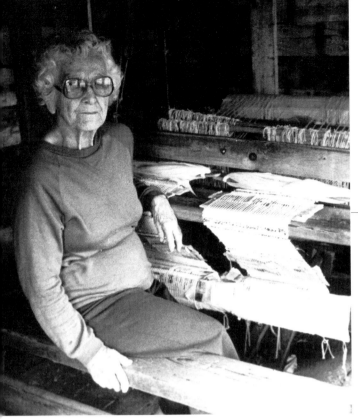

1989:79.1:17. Photo by Christine Saari.

Ellen Angman

CALUMET / HOUGHTON COUNTY • FINNISH-AMERICAN RAG-RUG WEAVER

Rag-rug weaving is a popular pastime throughout the United States. However, Finnish immigrants brought to the Great Lakes region a constellation of traditional rag rug (what they call carpets) techniques, standards, and sense of aesthetics that have been maintained unbroken. Ellen Angman (1908–2002) participated in this tradition for more than six decades.

Ellen's love of weaving rag rugs began in 1936 when her neighbor taught Ellen to weave, and, ultimately, gave Ellen the loom on which she wove her entire life. Even at 92 years of age, Ellen approached rag-rug weaving with enthusiasm, dedication, and skill. Neighbors, friends, and family laud her perfection of technique and combination of colors. To all who knew her, Ellen was a true master of rag-rug weaving.

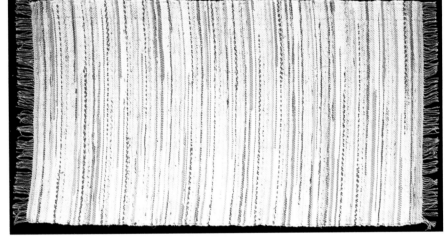

02-1992:97.1:68. Photo by Mark Eifert.

Throughout her life Ellen helped numerous local weavers with their weaving problems. She had the reputation of being able "to fix anything" and saved more than one frustrated individual from throwing away tangled warp.[1]

Over the decades, Ellen nurtured rag weaving in four generations of her extended family. She was the recipient of Michigan Traditional Arts Apprenticeship awards in 1992 and 1993. Two of her granddaughters have also received apprenticeships and have taught other friends and family and anticipate teaching their own grandchildren, the fifth generation. Ellen's unselfish sharing of knowledge played a significant reinforcing role in the maintenance of Finnish-American rag-rug weaving tradition.

Weaving occupied Ellen summer and winter, and, indeed, her weaving is widely known. However, her traditional knowledge also extended to crocheting, knitting, quilting, sewing, gardening, and cooking. She was a superb traditional cook and valuable resource for traditional Finnish-American foodways. This, then, is her legacy to Finnish-American culture and to her family, including two daughters, ten grandchildren, fifty great-grandchildren, and, at last count, fourteen great-great grandchildren.

1. Personal communication with Yvonne Lockwood. 1990.

Eddie Burns

DETROIT / WAYNE COUNTY • BLUES MUSICIAN

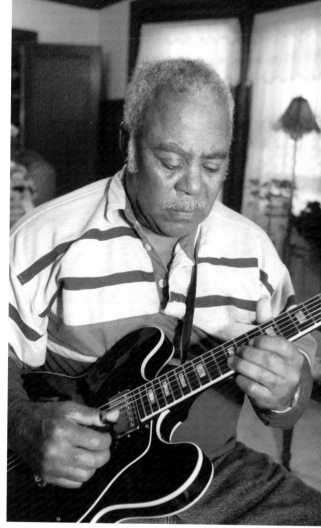

Eddie Burns (b. 1928) has carried the torch of African-American blues in Detroit since 1948. His presentation of the early country blues styles in a contemporary band setting is unique in Michigan. Although he has taken his blues singing, guitar playing, and harmonica playing to Washington, D.C., and on European tours, Eddie is one of the few blues musicians to live and perform continuously in Michigan.

Eddie grew up in the small Mississippi Delta towns of Wells and Dublin, where he heard country blues recordings in his grandfather's juke joint and listened to his father play blues on harmonica, guitar, and piano. His greatest influences from country blues recordings came from Tommy McClennan, Memphis Minnie, and Big Bill Broonzy on guitar and from John Lee "Sonny Boy" Williamson on harmonica. The harmonica was Eddie's first instrument as a boy. Playing "one string guitar" on the side of the house led Eddie to playing the six-string guitar.

After teaming up with blues guitarist John T. Smith in Davenport, Iowa, Eddie moved with John to Detroit in 1948. They played blues at house parties and eventually began to back up John Lee Hooker in performances and on recordings. When Hooker began touring nationally, he groomed Eddie to fill in for him at clubs and in recording sessions. Eddie moved toward the modern blues guitar style of T-Bone Walker by the early 1950s, and he adapted to the R&B sounds coming out of Motown and Stax labels. As blues gained a worldwide revival in the late 1960s, Eddie began touring European countries, playing blues throughout the 1970s.

Eddie's album *Detroit* on the U.S. label Blue Suit shows his deep roots and originality. The recording features country blues standards like "Bottle Up and Go" and "Blue Jay (Fly Down South for Me)" performed with fresh band arrangements. Eddie acknowledges the shared repertoire that is the mark of country blues: "There ain't no notes that never been played before; you just rearrange them in your own way."[1]

His maintenance of blues tradition while contributing new compositions and effects on the guitar and harmonica makes Eddie Burns a key bearer of the living blues tradition.

03-1994:20.7:21. Photo by Al Kamuda.

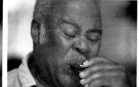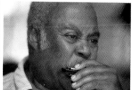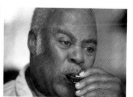

03-1994:20.3:4-7. Photos by Al Kamuda.

1. Personal communication with Ruth Fitzgerald, 1994.

1 9 9 4 | **55**

Nadim Dlaikan

Photo by Marsha MacDowell.

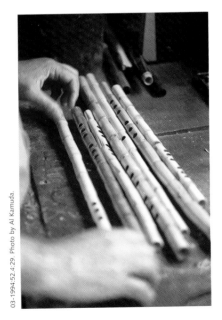

03-1994.52.4.29. Photo by Al Kamuda.

I n the dynamic musical community of Arab Detroit, "Nadim Dlaikan is highly respected as a talented and conservative defender of traditional Arab musical genres."[1]

His primary instrument, the *nay* (a single reed wind instrument) is difficult to master, but Nadim is a virtuoso on it.

When growing up in Lebanon, Nadim became interested in the *nay* at an early age when his brother brought one home. His family discouraged him from playing it, but Nadim persisted and before long made his own nay and taught himself to play it. His family eventually acknowledged his talent, and Nadim attended the Lebanese Conservatory to improve and strengthen his musical education under the tutelage of highly acclaimed musicians. When he graduated from high school and the conservatory, he moved from his village, Aley, to Beirut where he performed as a professional musician and frequently accompanied Lebanon's best folk music and dance troupes throughout the Middle East.

In 1970 at the age of 30, Nadim immigrated to the United States and worked several years as a musician in New York City and around the country. He settled in Detroit, which has the largest and highest concentration of Lebanese in the United States. After years of work, Nadim realized his dream when he quit his job, and today devotes himself completely to his music. His hobby is now his livelihood, and he plays throughout the United States as well as locally. Nadim explained, "I love the *nay*. It is a sensitive instrument, and I have to be sensitive to it, to play with feeling."[2]

In addition to making music, Nadim is the only *nay* maker in the United States.[3]

He grows bamboo in his back yard and makes a variety of Arab flutes. Musicians from around the United States order his instruments and send theirs to him for fine-tuning and repair.

Nadim is committed to teaching people about Arab and Middle Eastern music and reaching new audiences. He also explores ways in which Arab folk music can blend with world music and encourages local Arab musicians to use music to teach others about their culture and to expand their vision of themselves as musicians. He often is in a position of leadership, bringing together musicians for a performance.

1. Sarah F. Howell. Nomination statement for Nadim Dlaikan, 1993.
2. Personal communication with Yvonne Lockwood. 1993.
3. Sarah F. Howell. Nomination statement for Nadim Dlaikan, 1993.

Pushpa Jain

OKEMOS / INGHAM COUNTY • MEH'NDI ARTIST

The Indian community in Michigan is a multicultural group. Individuals have come from different regions of India with different cultural and social backgrounds, representing different religions, classes, and languages. They are Hindus, Muslims, Jains, Sikhs, Buddhists, Christians, Parsees, and Jews, speaking 16 languages and 225 dialects. With them, they have brought knowledge of traditions that play an important role in their lives as Asian Indians. *Meh'ndi*, the art of decorating hands and feet with henna, is an integral part of festive occasions.

03-1994:52.16:36. Photo by Al Kamuda.

Pushpa Jain was born in 1948 in Jaipur, Rajasthan, India, where, at the age of about ten, she began to learn about *meh'ndi* application from relatives and neighbors. She came to the United States with her family in 1985 and continues to practice the art of *meh'ndi* in her new community.

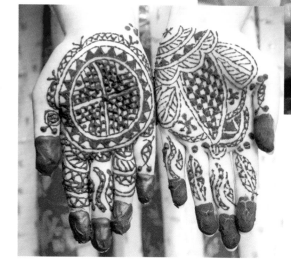

03-1994:52.15:18. Photo by Al Kamuda.

Meh'ndi application is something every girl tries; like makeup, a young girl embellishes herself and her friends in play. Pushpa, however, is regarded one of the best in the area and is often deferred to on questions of *meh'ndi* by others who have had some practice in this art. Her designs are recognized as having "outstanding artistic quality with the clearest of lines."[1]

Pushpa is a dedicated practitioner of *meh'ndi* tradition, teaching children and others in her leisure time. The community's gratitude is expressed in the words of one Indian: "Her willingness to work with the children has helped in developing interest in this art in the next generation [not born in India]."[2]

She also prepares the hands and feet of dancers before their performances and frequently is called upon to decorate the hands of other female community members in preparation for special events, and of brides for their weddings. Pushpa also readily shares her skill with the greater American community, demonstrating at festivals and at workshops with 4-H'ers and in this way educating others about Asian Indian culture.

1. Aparna Agrawal. Letter of support for nomination of Pushpa Jain. 29 November 1993.
2. Ibid.

Fr. Czeslaw Krysa

ORCHARD LAKE / OAKLAND COUNTY • POLISH-AMERICAN COMMUNITY LEADER AND PISANKI ARTIST

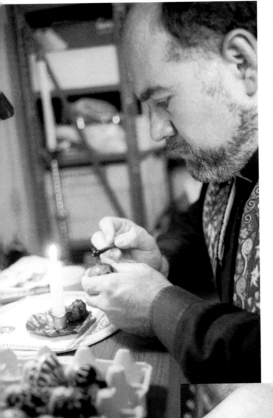

03-1994:8.1:3. Photo by Al Kamuda.

03-1994:8.19:28. Photo by Al Kamuda.

Enthusiasm for and dedication to Polish family customs mark Fr. Czeslaw Krysa as an outstanding bearer of Polish-American traditions, a promoter of traditional Polish art, and a cultural leader in the Polish-American community in Michigan. He is recognized and respected as an exceptional artist, creating numerous *pisanki* and weaving palms each year in preparation for Easter. These elements in combination distinguish Fr. Krysa as a community cultural leader.

Fr. Krysa (b. 1954) is a skilled practitioner of *pisanki*, the wax resist technique of "writing" Polish Easter eggs." There is no one single thing, other than cycling, that I have been doing longer than *pisanki*," he stated."[1]

He learned the batik method of egg ornamentation from his father, who would decorate eggs on the Friday and Saturday before Easter. Each year he would tell and retell stories of his aunt Stanislawa Paul in Poland who annually made more than 60 *pisanki* to give to friends and neighbors. As a young man Krysa traveled with his father to Poland where he met Aunt Pauline, as she was called, and was inspired to learn as much as he could about the traditions and designs related to *pisanki* in Poland. In this he was thorough and academic. He returned to the United States and shared his knowledge with members of the Polish-American communities. Through classes, lectures, and informal apprenticeships he dedicated himself to teaching and sharing these traditions.

He learned palm weaving from his elementary teachers, the Franciscan Sisters of Hamburg, New York. "During the week prior to Easter the Sisters channeled our energies, excited by the holidays, in a creative manner. They brought in leftover palm fronds from church and taught us how to weave them into flowers, grapes, and wheat designs. For us children, the weavings were the first joyous sign of Easter."[2]

As a leader among Polish-Americans, Fr. Krysa strives to reinforce traditions in the community. He supports the heritage of the community by aiding members in rediscovering their own family legacies of traditions through summer workshops and classes on family traditions. In 1993 and 2003 he received a Michigan Traditional Arts Apprenticeship to teach pisanki. His work to encourage an appreciation of Polish-American traditions in the community extends throughout the United States, and the revitalization of Polish customs in America through the efforts of Fr. Krysa has inspired pride in Polish heritage.

1. Susan Tipton. Letter of support for nomination of Fr. Czeslaw Krysa, 1992.
2. Fr. Czeslaw Krysa. Michigan Traditional Arts Program files. November 1993.

MICHIGAN HERITAGE AWARDS 1995

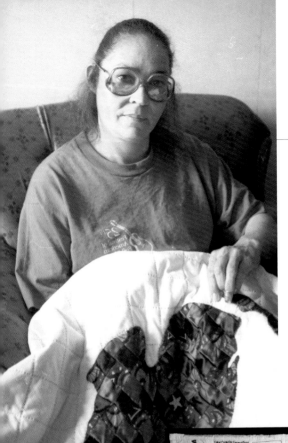

Deonna Green

REMUS / MECOSTA COUNTY • QUILTER AND TEACHER

Deonna Green (b. 1948), who learned to quilt from family members, grew up surrounded by the quilting traditions of her family and community. She makes quilts for many occasions, including birthdays, graduations, anniversaries, and the births of family members. Within her community, she contributes to quilting efforts that provide for neighbors in need after fires and other disasters.

Since 1983, however, Deonna has combined her skill as a quiltmaker and her interest and love for her family and community in creating unique documents of family and community history. Her cousin, Ken Todd, first had the idea for depicting family and community history on a quilt and encouraged Deonna who enlisted the help of her mother, Ione, and several other relatives to research family genealogy and oral history. Records of family history were unearthed in archives in Lansing, Detroit, Washington, Maryland, and Kentucky, and stories were collected of how the family eventually settled in Mecosta County. Deonna then led her family in designing and making a quilt based on their research. The resulting Todd Family Quilt illustrates, through embroidered text and images, the story of former slave Stephen Todd, his wife, Caroline Kahler, and six generations of their descendants.

03-1996:2.2:12. Photo by Mary Whalen.

7005. Photo by Pearl Yee Wong.

After completing two more versions of the Todd Family Quilt, Deonna continued to research area and family history and to make quilts recording her work. Since 1990 she has completed the Sawyer Family Quilt, the Green Family Quilt, and the Old Settlers' Quilt. Each quilt is painstakingly researched and executed; Deonna estimates that "it took her a hundred hours just to complete one block of a quilt."[1]

These quilts and others have been exhibited in local, regional, and national exhibitions.

Deonna has also been generous in sharing her remarkable talents with others. She has demonstrated quilting at Wheatland Festival, the Festival of Michigan Folklife, and the Festival of American Folklife in Washington, D.C. In addition to sharing her skills within the family, she has taught general quiltmaking techniques (in particular the steps of researching and producing a family history quilt) in museum and MSU Extension workshops and to 4-H groups and school classes in Mecosta, Lansing, and Detroit.

1. Interview by Marsha MacDowell. 26 January 1991.

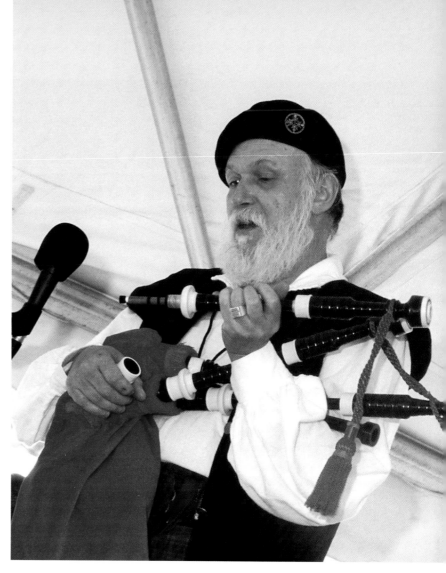

The Scottish heritage of D. J. Krogol's mother provided D.J. with his first introduction to bagpipes. D.J. (b. 1949) began to play the Great Highland bagpipes at age seven when he joined the St. Andrews Junior Pipe Band, sponsored by the St. Andrews Society in Detroit. At the time, his mother, whose family name is MacEadin, said, "Jerry has liked the pipes for as long as I can remember. We have them at our family get-togethers and I guess he just takes to them naturally."[1]

He continued his study with noted piper Walter Rose during his youth. From this beginning, he has become committed to the preservation of the traditional music of the Scottish pipes.

D.J. has shared this essential element of Scottish culture through many venues, playing at weddings, funerals, christenings, and anniversaries throughout the Scottish-American local communities. He has been his clan's piper since the age of ten, playing for clan reunions and other gatherings. He has shared his talent professionally with others by participating in senior citizens' programs, local school programs, charity fundraisers, and many theater productions, including *Brigadoon*.

D. J. Krogol

LANSING / INGHAM COUNTY • HIGHLAND BAGPIPER

D.J. is a committed performer with a firm and consistent command of the instrument's technique. Virtuosity and skill are revealed in the performer's mastery of more than 80 difficult grace note combinations. Few pipers have reached D.J.'s level of proficiency.

In addition to his skill as a performer, D.J. is a noted and dedicated teacher. Instruction on bagpipes remains primarily an oral tradition, passed from master to pupil. Beginning at age 20, D.J. actively maintained this vital tradition, engaging students and reaching out to community groups across Michigan. In 1995 and 2002 he was awarded Michigan Traditional Arts Apprenticeship grants to further this tradition in Michigan. His students are also committed to continuing this traditional music form and speak highly of D.J.'s skill as an instructor. They note his attention to detail, his enthusiasm, and his particular concern for emotive quality.

D.J. Krogol is honored for his skill as a Great Highland bagpiper and his singular dedication to the preservation of this musical form through performances and other teaching opportunities.

1. Cited in Floyd Thomas, "This Piping School Is No Pipe," *Detroit Times*. n.d.

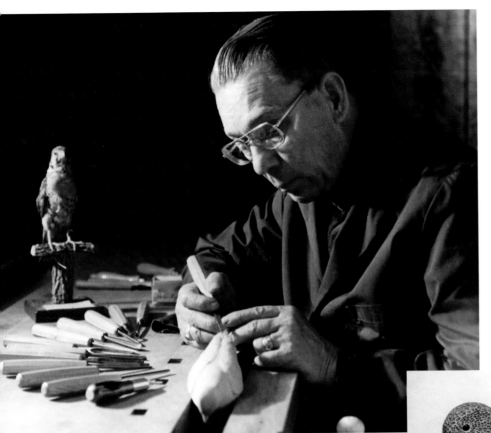

K en K. Krum (b. 1914) has been carving duck hunting decoys for nearly 50 years. His carving style is firmly connected to the traditional functional purpose of decoys; Ken's decoys are meant to be hunted over. They are considered good when they are effective, and his decoys have been effectively used many times to lure waterfowl from the sky to his dinner table.

Ken credits lifelong friend and hunting partner, Dr. Miles D. Pirnie, as

Ken K. Krum

1993.99. Photo courtesy of Ken Krum.

MARSHALL / CALHOUN COUNTY • DECOY CARVER

the primary influence on the design and carving of his decoys. Miles, well known in the Michigan waterfowling community for his depth of knowledge about waterfowl and waterfowl hunting, helped hone Ken's skills of observing and replicating the details that distinguish one waterfowl species from another. Willy McDonald, another fellow carver and duck hunting partner, once asked his friend why no two decoys in his set looked alike. Ken answered that it was his observation "that feeding Mallards display various attitudes ranging from quiet to aggressive." Willy realized Ken's goal was to duplicate the flock.[1]

Ken has always been willing to share his skills with others but only recently was made aware of the influence he himself could have on future generations of carvers. To this end he has taught both his son and grandson to carve. "Grandpa Krum" has passed on to them and many others a rich heritage in the production of a unique art form and a deep appreciation for nature.

Recently Willy curated "Artful Deception," an exhibition that examined the work of several regional Michigan decoy carvers and their influence on each other. Ken's work was included for several reasons: it remains true to the original intention of this carving tradition—the creation of working decoys for use in hunting; it reflects his lifelong commitment to the craft; and it demonstrates his development as a tradition bearer over the course of his lifetime.

1. Willy McDonald. *How to Carve a Hunting Decoy.* http://theduck-blind.com/cyberclassroom/hunt-ingdecoyarticle1.htm 15. May 2002.

MICHIGAN HERITAGE AWARDS 1996

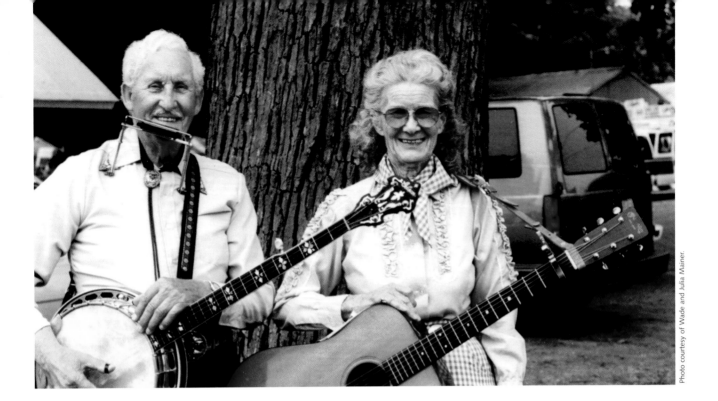

W ade and Julia Mainer have done what all great folk artists have always done: they received their music from earlier generations, gave it their own special shape and stamp, and passed it on to younger musicians. They have played exemplary roles in preserving old-time Appalachian music and hold a special place in southern musical history.

As a fine singer and guitar player, Julia had her own radio program in the 1930s. A deeply religious woman, Julia specializes in gospel songs. In addition to solo work, she has served as Wade's guitarist in concerts and on records and she also sings harmony with him.

Wade, a living legend of traditional mountain music, grew up in a musical family from his birth on April 2, 1907. He learned to play the banjo, which became his specialty, by watching local musicians at Saturday night barn dances. In the 1930s he began his musical career, joining with his older brother, J.E., to form the string band Mainer's Mountaineers. He soon formed his own group, Sons of the Mountaineers, and continued to record and work in radio until 1953 when he moved to Flint to work for General Motors. Wade's large recorded repertoire in the 1930s served as a bridge between the older mountain music and the Bluegrass style of the 1940s and 1950s. He was one of three musicians who kept the five-string banjo and its old-time repertoire in the public eye through records and the radio until the arrival of musicians such as Earl Scruggs.

Wade & Julia Mainer

FLINT / GENESEE COUNTY • OLD-TIME APPALACHIAN MUSICIANS

During the early 1950s, Wade and Julia gave up musical entertainment, singing only in religious services. Persuaded years later that the banjo and gospel music were compatible, they returned to public performance, and by 1961 had begun to record again. After Wade's retirement in 1973, he and Julia began to perform at bluegrass festivals, concentrating on mountain gospel music with an occasional old and rare secular piece. They have been together in marriage and music for 63 years. In 1987 Wade was awarded a National Heritage Fellowship for his role in the development of two-finger banjo picking in the style of his native western North Carolina.

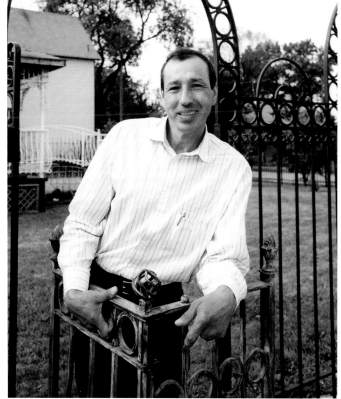

Ornamental ironwork is a widespread Hispanic tradition, and Tony Martinez (b. 1948) is a key figure in the perpetuation of that tradition in Detroit. Tony was born in Cadas in the southwest region of Colombia, where almost every house has window guards and decorative doors and gates made of ornamental iron. In Tony's mind, "a typical street scene has scrolled ornamental iron displayed everywhere."[1]

Members of the Martinez family have been ironworkers for a number of years, specializing in a type of ironwork known as the Spanish scroll style. Tony first learned his ironmaking skills by watching his uncle in Colombia and, after immigrating to Detroit, by working with his brother Joe. In 1971 Tony and his brothers established a decorative iron business. Eventually Tony took over the business, re-named it

Diseños Ornamental Iron, and relocated it in the heart

DETROIT / WAYNE COUNTY • ORNAMENTAL IRON WORKER

of Detroit's Mexican Town. He employs a year-round staff of four and as many as thirty skilled and experienced ornamental ironworkers during busier times of the year. Many of the seasonal workers are from Latin American countries and, after the busy season is over, some return home.

According to Tony, "this is hard work, you really need sometimes to concentrate working 12–14 hour days."[2]

His and his employees' hard work has paid off and the products of Diseños Ornamental Iron are evident in windows, doors, gates, and fences throughout Mexican Town. Tony even designed and fabricated a special Mexican Town logo that is affixed to lampposts in Mexican Town.

Because of Tony's dedication to fine craftsmanship and his skill in creating new designs in iron, he is now greatly in demand by architects and building contractors for crafting ironwork. He is counted among a select group of artisans whose high-quality work is suitable for both new buildings and for restorations of older buildings. As a result, his Spanish scroll traditional ironwork as well as innovative designs can now be seen on private and public buildings throughout the metropolitan Detroit area.

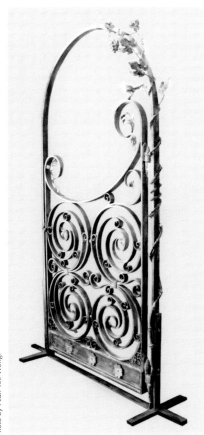

Photo by Pearl Yee Wong.

1. Personal communication with Kurt Dewhurst. 16 September 1994.
2. Ibid.

MICHIGAN HERITAGE AWARDS 1997

Paul Hagemeister

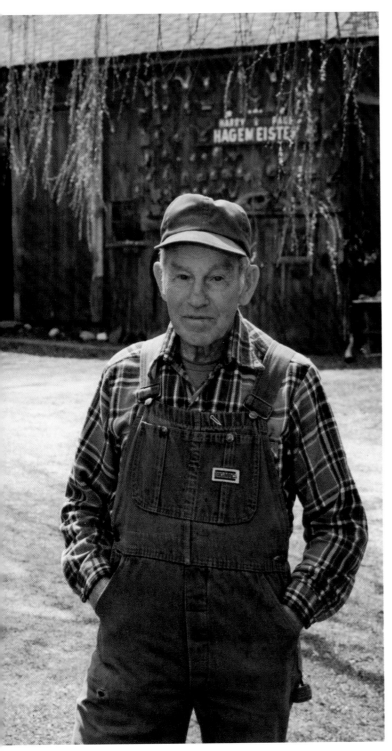

Paul Hagemeister (b. 1911) is a master timber-frame barn builder and an advocate for barn repair, restoration, and adaptive use. In 1935, Paul began an apprenticeship with Frank Havens in the building of timber-frame barns. The skills and knowledge to build most of our rural vernacular architecture were passed on from generation to generation through such informal apprenticeships. Young men, working with fathers, uncles, or neighbors, learned a skill to be carried into the future to serve the next generation. This chain of learning began to weaken in the nineteenth century and came to a virtual halt in the early twentieth century. Changes in our society, agricultural practices, and technology made the construction of the time-honored timber-frame barns obsolete.

Only a few remain who apprenticed during the time when the last timber-frame barns were built in the 1930s and who continued in that line of work throughout their lifetime. Paul continues to be a student of barns, knowing that by keeping an open mind he will continue to help refine and improve techniques that might make a difference in restoring or adapting timber-frame structures today. He has brought young people into this line of work and taught them and is delighted at the increasing interest in rural preservation as it draws attention to farm structures, advocates adapting and reusing barns, and keeps them on the landscape.

Paul is especially notable because of his preservationist ethic and his role in the movement to keep timber framing skills and knowledge alive. Throughout his career, he has taught builders and barn owners about timber framing and continues to share his experiences and knowledge with others. As a "student of barns," he refines methods and techniques to preserve and reuse more of the existing timber barns throughout the state. His efforts have helped to call attention to these noble structures. Increasingly owners are encouraged to repair their barns and rural buildings, and young builders and contractors look to him for direction.

For a lifetime as master timber framer, teacher, and preservationist, Paul plays an exemplary role maintaining the traditional farmstead and rural landscape of Michigan and holds a special place in Michigan architectural history.[1]

1. Based on field reports and nominations by Julie Avery and Steve Stier.

03-2001:189.1:1. Photo by Mary Whalen.

Lula Williams

DETROIT / WAYNE COUNTY • QUILTER

2001:189.5:1. Photo by Mary Whalen.

As a young child, Lula Williams (b. 1925) occasionally helped her mother with her quilting by putting colors together and piecing. However, she only returned to quilting in the early 1980s when her 13-year-old son encouraged her to take a course in it at his school; she remembered her mother's techniques almost immediately and has been quilting ever since.

Lula has made more than 120 quilts and won numerous awards. Her work reflects many traditions within her experiences. She is a needleworker keenly interested in the latest techniques and patterns; she is an African American committed to conveying information about her heritage; she is a woman of faith who communicates her beliefs through her quilts; she is an individual proud of being an American. One series of her quilts incorporates African cloth, paying homage to Martin Luther King, Jr. Another series is of red, white, and blue cloth with designs of stars and stripes. A special quilt, her original "I Am" design, depicts the several times Jesus utters "I am" in the Bible as well as the declarations of "I am" by African-American preachers in their sermons. She is perhaps best known for her baby quilts, of which she has made scores as gifts for family and friends.

02-1991:1.1:35. Photo by Mark Eifert.

Lula's excellent craftsmanship has won her a number of awards and invitations to participate in shows within the African-American community and beyond. In addition she has taught quilting for a number of years at the Evans Recreation Center on Detroit's northeast side, at the Michigan State Fair Senior Center, and at Detroit's westside Tindal Recreation Center and readily assists those who seek her help. She also has been recognized with awards of Michigan Traditional Arts Apprenticeship grants to teach her skills to other aspiring quilters in her community. She has demonstrated her quilting at the Festival of Michigan Folklife, the National Folk Festival, and the Great Lakes Folk Festival.

William Stevens

Vocalist, guitarist, and square dance caller, William Stevens (b. 1934) is a major driving force behind the continuity of Grange Hall music in Michigan today. With both parents calling and playing at local house parties and square dances, William has spent his life in the Grange, with its music and traditions dear to him. His repertoire includes older, traditional tunes as well as some newer tunes, in keeping with the changing tastes of the audience.

In the 1970s, the Tag-A-Longs trio was formed in Charlevoix, which included William as a founding member. At that time, the group won the talent competition at the National Grange Convention, and William went on to win numerous talent competitions at State Grange. As the house band for the Barnard Grange, the Tag-A-Longs and "Mr. Music" or "The Music Man," as William is called in Grange circles, continue the tradition of Grange Hall square and round dances. Barnard Grange, one of the largest in the state, is unique in that it is one of the few that still regularly put on old-time square dances. It is more common to have a DJ or more contemporary band play at Grange dances. These dances are not just for the Grange, but also for the whole community.

Under William's leadership, the group plays a key civic role, engaging in the many voluntary charitable and community service activities for which the Grange is known. The Tag-A-Longs maintain an active schedule of Grange Hall dances and fundraisers, barn dances, nursing home performances, antique tractor shows, fiddlers' jamborees, and local festival appearances.

One of William's greatest contributions to the perpetuation of Grange music and dance is his encouragement of others. He is instrumental in keeping dance callers and musicians involved in the tradition. Bringing the older and experienced together with the younger generation, he readily steps aside to feature others.

William is well known throughout the region for his dedication to the continuance of Grange music and traditions. His leadership as a prime mover and fine musician and vocalist has helped to make Barnard Grange the center of Grange music and dance in Michigan.

03-2001:189.3:1. Photo by Mary Whalen.

03-1989:3.2:32. Photo by Jim Leary.

MICHIGAN HERITAGE AWARDS 1998

Anna Crampton

Born in 1927 and raised in Rosebush, Anna Crampton (Saginaw Chippewa/Grand River Ottawa) is an enrolled member of the Saginaw Chippewa Tribe. She is a highly respected elder of the tribe located in Mt. Pleasant and a regular participant in pow wows and other Native American cultural and social events. Anna relocated to the Lansing area in the late 1940s and is currently on the board of Nokomis Learning Center in Okemos.

Anna learned basketmaking primarily from her parents, Michael and Eliza Jane Peters Neyome; Eliza learned in turn from her mother and grandmother who were also basketmakers. Because the children in the Neyome home grew up watching their parents make baskets, Anna testified "all my brothers and sisters all knew how to do basket weaving. And the women that my brothers married, they also learned from my mother."[1]

Anna spends much of her time demonstrating the art of black ash basketweaving. In her teaching, she practices the same techniques and styles used by both her mother and grandmother. Three of her children make baskets, including Marclay who, with Anna, attended the 1997 Southwest Native Basketmakers Gathering in Arizona. For many years, Anna's husband, John, assisted by pounding the ash and accompanying Anna to basketmaking events.

Anna has worked hard to maintain Native American traditional arts, striving to locate new markets and strengthen the network of communication between artists. She was involved in the formation of the Great Lakes Indian Artists Association and in "Sisters of the Great Lakes," a project of the Nokomis Learning Center. She has been a participant in the Great Lakes Folk Festival, Festival of Michigan Folklife, a master artist in the Michigan Traditional Arts Apprenticeship Program, and a primary force in the first Great Lakes Basket and Quillbox Makers Gathering held August 1997 in East Lansing.

Throughout Michigan, Anna's black ash basketweaving is highly praised. Her willingness to share her expertise has contributed to her notoriety. She continues to remain involved in the artistic traditions of her native heritage, attempting to maintain and perpetuate them by teaching young people.

03-2001:182.14:7. Photo by Mary Whalen.

03-2001:182.14:19. Photo by Mary Whalen.

1. Interview by Betsy Adler at the Great Lakes Indian Basket and Boxmakers Gathering, East Lansing, Michigan. August 1997.

I n the Keweenaw Bay Indian Community, located in the Upper
Peninsula of Michigan, Lois LaFernier (b. 1925) holds the presti-
gious position of storyteller. Fellow tribal members have described
her as "a sensitive, caring person who sees and responds to the needs of
the community.[1]

Despite physical limitations, Lois has dedicated her life to the
health and education of others within her community, reaching out,
whenever possible, to those outside of the tribal community.

A dominant member of the Ojibwa Senior Citizens, she helped the
group implement a meal program for senior citizens and raise money for
the operation of a private building. Her efforts to recruit tribal elders as
bereavement volunteers were also successful.

Lois's sensitive persona was a priceless asset to her position at a
local hospital nursery. She not only contributed to her family's needs,
but also made the Native Americans feel as though they had a friend
amidst the hospital staff. Fellow
nurses considered her a valuable
resource in transcultural issues
involving health care.

A storyteller, Lois educates
the community about Ojibwa
methods of hunting and fishing,
food preparation, history, and
traditions in her column in
Ojibwa News, the tribe's monthly
newsletter. She also volunteers a
column for the community's
monthly health department
newsletter; her writings use con-
ventional tribal teaching to
address health problems in con-
temporary society.

Lois's activities extend not
only to the adults of the commu-
nity, but to the youth as well. Serving as storyteller in summer youth programs held at her home and
donating time to a group home for severely troubled children are just a few of the ways she reaches the
younger generation.

03-2001:182.4:1. Photo by Mary Whalen.

03-2001:182.3.25a. Photo by Mary Whalen.

Lois LaFernier

L'ANSE / BARAGA COUNTY • OJIBWA CULTURAL AND HISTORIC PRESERVATION LEADER

1. Naomi Haycock. Letter of nomina-
 tion for Lois LaFernier. 1 December
 1997.

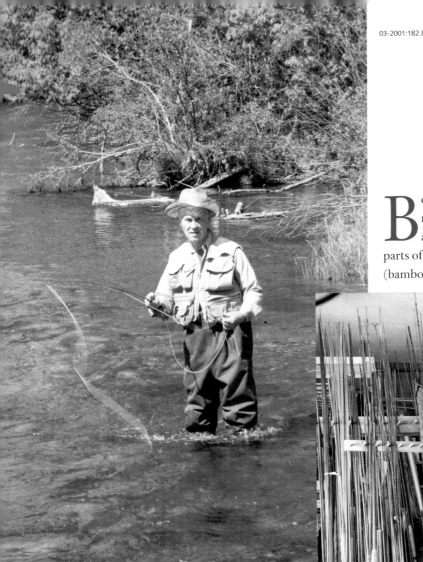

03-2001:182.8:10. Photo by Mary Whalen.

03-2001:182.8:36. Photo by Mary Whalen.

Bob Summers

TRAVERSE CITY / GRAND TRAVERSE COUNTY • BUILDER/PRESERVER OF BAMBOO FISHING RODS

Bob Summers (b. 1938) constructed his first fly-fishing rod at the age of 16. He has since perfected the craft and become known throughout Michigan and other parts of the country as the foremost maker of tonkin cane (bamboo) fly-fishing rods.

Bob believes fly fishing "puts you in a state of mind."[1]

He began fishing when he was seven years old and owned his first fly rod at the age of ten. Later, he was employed with the Paul Young Company in Detroit, a business known for its tackle and rods. Here he learned his exceptional skill of making bamboo fly-fishing rods. His rods, along with those of others, were featured in the exhibit *Caught on the Fly: Fly Fishing Traditions in Michigan* at the Michigan State University Museum.

A characteristic that makes Bob's rods unique is that virtually every component is made from scratch, including the case. His materials include cork, metals, and tonkin cane. He has even assembled a variety of metal presses and other mechanical tools to assist him in his creations.

In 1956, Bob moved to Traverse City and began his own rod-making business. His fly rods are in demand all over the world and are considered collectors' items as well as cherished equipment; these handcrafted objects are so appealing that there is a waiting period of years rather than months when ordered. The name "Bob Summers" is constantly mentioned when the subject of bamboo fly rods is discussed in the fly-fishing community.

Bob strives to maintain the importance of the bamboo rod amidst the fiberglass and other synthetic rods. One of his methods is teaching his skill to others. His pupils, many of whom are scattered throughout Michigan, regard him as an "exciting and skilled artist and technician."[2]

His efforts to maintain and preserve the tradition of tonkin cane rod making, coupled with his superior skill in crafting it, have earned him recognition as one of Michigan's finest makers of bamboo fly-fishing rods.

1. Personal communication with Kurt Dewhurst. 1998.
2. "1998 Michigan Heritage Award Winners," in Yvonne Lockwood and Marsha MacDowell, eds. *1998 Michigan Folklife Annual*. East Lansing: Michigan State University Museum, 1998, p. 83.

MICHIGAN HERITAGE AWARDS

1999

03-2001:180.7:1. Photo by Mary Whalen.

The Cadieux Cafe Feather Bowling Club was established in 1933 in Detroit. The club bowls at the Cadieux Cafe, which continues to be a center for Belgian-American gatherings and activities. The Cafe's large sign announces it is the "home of Belgian sports." Belgian (Flemish) feather bowling, pigeon racing, bike clubs, and traditional Belgian food have a strong presence here.[1]

Feather bowling entails rolling a wooden, cheese-shaped ball down the Cadieux's dirt-packed, curved alleys, getting as close as possible to pigeon feathers stuck upright in the dirt on

Cadieux Cafe Feather Bowlers

DETROIT / WAYNE COUNTY • FEATHER BOWLERS

either end. Each night of league play, the club members divide up randomly into teams according to their "class," which indicates their experience. Each team is ideally made up of three players, one from each class. After flipping a coin, the first team typically rolls the first two balls close to the feather, and then rolls the rest of their balls into places that serve as "blocks" to any other balls. The second team's players try to weave their balls in and out between the blocks or knock the blocks out of the way, with the final bowler attempting to gain a better position than the first team. A referee determines the score for each round. Rounds continue until one team reaches ten points. While the bowlers play, spouses socialize and restaurant patrons wander in to watch the action.

03-2001:180.7.7. Photo by Mary Whalen.

Feather bowling and the Cadieux Cafe have come to symbolize Belgian identity for the Belgian-American community. The Cadieux Cafe Feather Bowling Club members' commitment to the traditional sport is a sign that feather bowling captures and expresses familial, ethnic, local, and global connections for Belgian-Americans in the Detroit area. Many of the bowlers are also members or officers of the Belgian-American Association and the Belgian Century Club. As a consequence of their dedication to the game, they have helped to create a social and cultural context in which Belgian culture and other traditions are shared and strengthened.

1. Janet Langlois. "Feather Bowling and Floor Bowling in Detroit's Belgian Community." in Yvonne Lockwood and Marsha MacDowell, eds. *1998 Michigan Folklife Annual.* East Lansing: Michigan State University Museum, 1998, p. 19.

Melvin Kangas

PELKIE / BARAGA COUNTY • KANTELE PLAYER

Melvin Kangas (b. 1933) is a highly acclaimed Finnish-American kantele virtuoso and teacher. The kantele is an ancient instrument in the zither family and regarded as the national instrument of Finland. In the late nineteenth and early twentieth century, Finnish immigrants regarded the kantele as sacred. Tradition recalls its mythic origins, and *The Kalevala*, the Finnish national epic, describes it played by legendary heroes. Although it is doubtful that immigrants brought the kantele with them when they left Finland, some had the knowledge and skills to make it once they arrived in this country.

As a child in Pelkie, Melvin had his first encounter with the kantele through a local Finnish immigrant. Years later, he was one of the first Finnish Americans to study the kantele in Finland. For two years he studied with Ulla Katajavuori, one of the most respected kantele masters of the time. Melvin says, "You can study with someone for a certain period of time and then you need to learn on your own."[1]

Melvin proceeded to do this, perfecting his skills and learning new music. After his return to Michigan, he became a music instructor at Suomi College (now Finlandia University), Hancock, where he teaches the large kantele privately and in classes to many enthusiastic Finnish Americans.

03-2001:76e.1:10. Photo by Mary Whalen.

Melvin has become a central figure in Finnish-American musical life. He performs at weddings, summer solstice celebrations, house parties, the Baraga County fair, and the Ottawa Sportsman's Club dinners. He plays a variety of songs, some traditional and some that he has

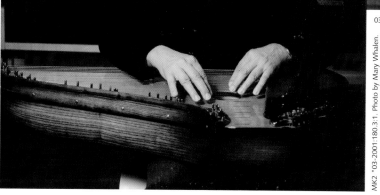

MK2 "03-2001:180.3:1. Photo by Mary Whalen.

arranged or composed for the kantele. For example, he often plays music that second-generation Finnish Americans heard in their childhood: humorous sauna songs, drinking songs, polkas and schottisches, lullabies, and religious pieces.

The kantele has been a focus of a Finnish-American cultural renaissance in the last decades. Melvin has played a major role in the spread of kantele music and the revival of kantele playing. Many musicians and teachers of Finnish descent have studied under his tutelage.

1. Melvin Kangas. Michigan Traditional Arts Apprenticeship Program application. November 1999.

Frederick Wenson

FARMINGTON HILLS / OAKLAND COUNTY • PALM FROND BRAIDER

03-2001:180.11:1. Photo by Mary Whalen.

P alm-frond braiding is a widespread Christian custom associated with Palm Sunday. In many cultures, worshipers take blessed palm fronds home from the Palm Sunday service. Sometimes the fronds are braided or twisted into crosses, amulets, and other objects and given to family and friends who keep them until the next Palm Sunday.

In the Wenson family, palm braiding has developed into a treasured tradition. In the 1930s, Katherine Marie Hunzicker Wenson was asked by her church, the Blessed Sacrament Cathedral in Detroit, to braid palm fronds for each of the ten to twelve celebrants of the Palm Sunday mass. She recruited her son Frederick ("Fritz"), then thirteen, to help. Until then, Katherine Wenson had made small items braided from palm such as crosses and boxes for children to take as gifts to teachers and nuns at school. "My mom was never taught what she did with palms," Fritz remarked. "When she was in grade school the nuns taught a class on how to make little crosses with palms but nothing like what mom developed herself."[1]

Fritz's mother created large, elaborate floral-like bouquets from palm fronds. With Fritz she braided palm fronds for the archbishop of the greater Detroit Archdiocese of the Roman Catholic Church, who carried them in the Palm Sunday procession. It soon became a family tradition for mother and son to compete in providing two separate palms from which the archbishop would choose. When Fritz's was finally chosen, he knew he had achieved greater mastery of the art. After arthritis restricted his mother's activity, Fritz continued the family tradition, eventually teaching his children. He and his son, Tony, who is most interested in braiding the palms, continue the intergenerational rivalry to see whose palm will be chosen by the archbishop. What started as a simple kindness toward the clergy by his mother has evolved to a deeply personal symbol of the Wenson family's commitment to their church and to each other.

1. Interview by LuAnne G. Kozma,
 Farmington Hills, Michigan. 9 April
 1995.

MICHIGAN HERITAGE AWARDS 2000

Henry Engelhard

BAY PORT / HURON COUNTY • ORIGINATOR, SUPPORTER, AND PROMOTER OF BAY PORT FISH SANDWICH FESTIVAL

2001:181. Photo by Mary Whalen.

1. Personal communication with Yvonne Lockwood. 1997.

02-1997-77.3.30.

Bay Port is a small community in Michigan's "Thumb" located on the shores of Saginaw Bay on Lake Huron. Bay Port's story is centered on fish and fishing, and one of the key persons in this story has been Henry Engelhard. He was "Mr. Bay Port." His entire life, until his death in 2001, was dedicated to the promotion of Bay Port and Bay Port fish.

In 1978 Henry and Edna Engelhard established the Bay Port Fish Sandwich Festival to attract visitors and friends to the town. They had been making and selling this very popular sandwich off and on since 1949. When the Bay Port Chamber of Commerce needed a fundraiser to promote Bay Port, Henry saw "the potential for the fish sandwich" with the boatloads of fish brought into the harbor daily.

Every August, the entire community comes together, presenting Bay Port and its attractions to visitors. The fish sandwich is the prime attraction. Mullet (herring was first used) is dipped in a secret batter, fried crisp, and served on a long bun with ketchup and mustard. Although not traditional, tartar sauce is also available. According to Henry, the fish should overlap the bun and the sandwich should be so large "it takes two hands to hold it." All day, the lines in front of the sandwich stand are long. It is not unusual to sell 12,500 sandwiches to people from as far away as Florida and the northeast.

Henry was the festival's primary inspiration, energy, supporter, and promoter. He wrote many stories regaling the fish sandwiches' power to please and to heal. Through his efforts, the festival has been featured on the *Today Show*, *20/20* , and in many national magazines and newspapers. In recognition of their contribution to the Fish Sandwich Festival, Henry and Edna (she died in 1992) were honored as "Mr. and Mrs. Bay Port." Henry once said about the festival that it has been "the greatest thing for the town of Bay Port. What makes me happy . . . is we made use of an under-utilized species."[1]

Deacon Albert Likely

POSTHUMOUS AWARDEE • DETROIT / WAYNE COUNTY • SINGER, LEADER, AND TEACHER OF LINED OUT METERED HYMNS

Albert Likely (1924–98) was a devoted deacon in Hartford Memorial Baptist Church (Detroit) and a master performer and committed teacher of the metered hymn. Created by black slaves in America, metered hymns are tunes led by a deacon or preacher with a good voice who defines the tune by chanting the lines of the hymn, which is called lining out. His lines are repeated in harmony by the congregation. The notes were not written but remembered and passed from one generation to the next. Many of these tunes have been lost.

Deacon Likely knew former slaves in his family near Evergreen, Alabama, who taught him metered hymn singing. His grandfather sang them as he farmed his land, and Deacon Likely recalled that the hymns drew others to the side of the road where impromptu church meetings evolved. His mother's tradition was to begin Christmas Day with a metered hymn rather than a holiday carol. By the age sixteen, Deacon Likely had become a metered hymn singer, too, and sang as he performed his farm chores.

03-1989:78.2. Photo by David Perry.

When he moved to Detroit, Deacon Likely discovered that in virtually every church at least one person could perform metered hymns. When he joined Hartford Church, his gift was discovered and older deacons often sent new or younger deacons to his home to learn the art of lining out a hymn. Deacon Likely was unique in his ability to remember hymn tunes and to teach them. Because of Deacon Likely, many on the Board of Deacons at Hartford are adept at lining out and combining the right lyric with the correct tune and meter.

For several years, Deacon Likely participated in the Michigan Traditional Arts Apprenticeship Program as master teacher of several young deacons at Elyton Baptist Church. He also taught new generations of deacons in Pilgrim Baptist Church and instructed, inspired, and trained deacons of the Baptist churches in the Progressive National Baptist Convention to sing and lead metered hymns.

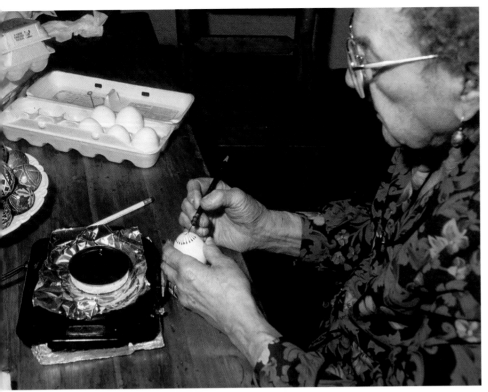

02-2001:181.1:3. Photo by Mary Whalen.

Mary Torsky, born in 1912 and a resident of Cedarville since 1948, first began practicing pysanky at the age of ten. Pysanky is a complex process of decorating eggs with the use of wax and colors. Under the supervision of her mother, an immigrant from the eastern Carpathian Mountains, Mary used straight pins to draw her designs. Only later did Mary acquire a stylus, which she taught herself to use, but she frequently still uses straight pins.

Concerned with maintaining family and ethnic traditions, Mary has taught her children, grandchildren, great grandchildren, and two daughters-in-law the art of pysanky. "I wanted all my children to be able to decorate eggs." She also goes into the schools to teach local children about pysanky. "I have taught people in the community for decades. Their names are too numerous to recall.[1]

Mary was commissioned to decorate an egg with a Michigan theme for an Easter egg display in 1998 in the White House. She applied icons imbued with Christian symbolism that also were charac-

Mary Torsky

CEDARVILLE / MACKINAC COUNTY • PYSANKY ARTIST

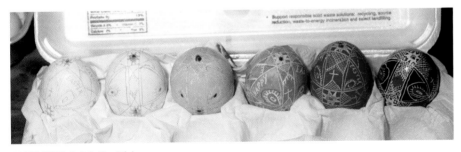

02-2001:181.2:3. Photo by Mary Whalen.

teristic of Michigan: white pine, deer, gulls, and fish. She also added the Mackinac Bridge and cherries. This egg is now part of the White House permanent collection.

In Mary's family, *pysanky* were given as gifts to family and friends. Today Mary decorates eggs for every occasion and continues the tradition of giving pysanky. In 1999, for example, she decorated twenty-four Christmas eggs for her grandchildren; she gave each child of her church an egg at Easter in 2000; she presented then Governor Engler a Michigan egg similar to that decorated for the White House display. Mary often donates eggs for fundraisers.

When Mary and her husband, John, moved to Cedarville, they established Torsky's Resort. Although the resort now belongs to her son, Mary still keeps very busy. In addition to *pysanky*, she maintains her own home, including mowing her lawn, and runs a bed and breakfast; she bakes, cooks, makes wine, and arranges wreaths.

1. Mary Kostecki. Letter of nomination for Mary Torsky. December 1999.

Irene Vuorenmaa

Ask about rag-rug weaving in Ironwood and chances are you will be directed to Irene Vuorenmaa, a master of this tradition. Born in 1935 in Kortesjarvi, Finland, Irene came to the United States in 1959 on a visit. She met her husband and has lived in Ironwood ever since.

Like many Finnish girls, Irene learned to weave at a young age from her mother. She wove rugs, curtains, bedspreads, and tablecloths. At 15 she was selling her rugs. When she settled in the United States, she resumed weaving on a four-harness loom. In the early years of settlement, Finnish immigrants also wove a variety of textiles on four-harness looms. In a short period of time, however, they were weaving only rag rugs. Their four-harness looms were altered to two, because of the ease and speed this afforded. Today, Irene weaves with both four- and two-harnesses on a loom made by a Finnish immi-grant almost 100 years ago. Her favorite pattern is "over the waves" (*Aanisjarven aallot*) which she learned in Finland.

For 27 years, Irene worked at a local nursing home. After work, she went home to her loom. "It was peaceful," she said, "to come home and do something else."[1]

She gets great pleasure from weaving, and she has helped many weavers get started. Irene's fame spread beyond the western Upper Peninsula when her family was fea-tured in the documentary film *Finnish American Lives* by Michael Loukinen[2] and when she partici-pated in the 1998 Smithsonian Folklife Festival.

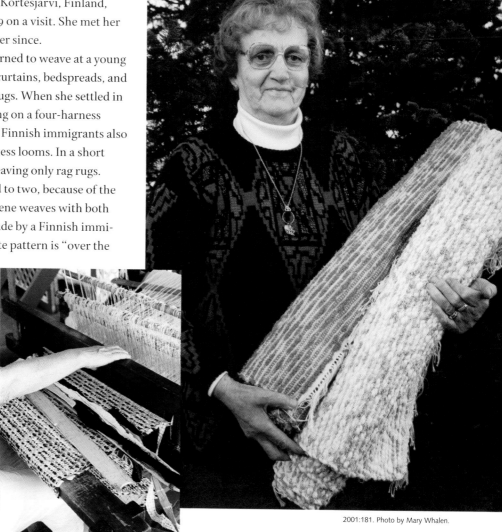

2001:181. Photo by Mary Whalen.

03-2000:76k.2:11. Photo by Mary Whalen.

Honored for her masterful weaving of rags, Irene also has a widely known reputation as a keeper of many Finnish traditions. She teaches Finnish folk dances, excels in making traditional Finnish foods, actively participates at the local Finnish cultural center, sings in the Finnish chorus, and volun-teers with 4-H youth. Ruth Olson of the Center for the Study of Upper Midwest Culture describes her as an articulate spokesperson for her culture. "Irene deserves . . . recognition not only because of her skill as a rag rug weaver but also because of her many other contributions to the preservation and con-tinuing health of Finnish-American culture in the Upper Peninsula and northern Wisconsin."[3]

1. Interview by Yvonne Lockwood and Martha Brownscombe, Ironwood, Michigan. 1986.
2. Michael Loukinen. *Finnish American Lives*. VHS, 57 min. Up North Films, 1982.
3. Ruth Olson. Letter of nomination for Irene Vuorenmaa. 8 December 1999.

Restore Douglass

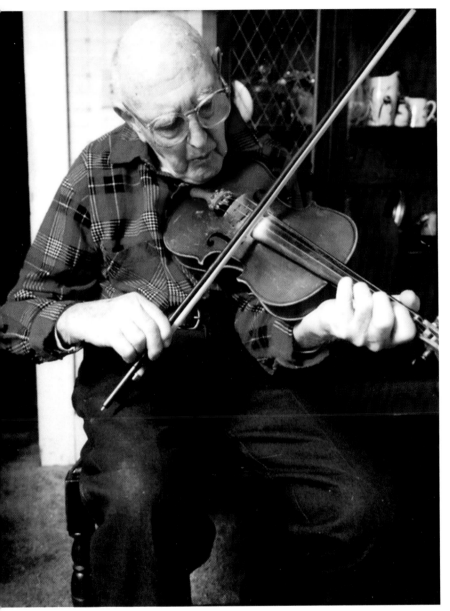

03-2002:26.3:5. Photo by Mary Whalen.

Restore Douglass, known by his friends as "Goog," was seven years old in 1914 when his father bought him his first fiddle. He has many stories to share about his years of fiddling, one of which is about learning to play. After two lessons, his instructor left. In 1919, Burn Devoe, then ninety-four years old and one of the best fiddlers in the county, agreed to stay with the family for two days and teach young Goog to play. And play he did. As Goog states, "I've been at it ever since."[1]

He even helped feed his family during the Depression by playing at weekly square dances. In his early nineties, he is still an active musician, playing in church and at house parties, jamborees, dances, and community events such as sidewalk days and senior citizens' activities.

Goog is credited as having perpetuated old-time music by sharing tunes he has played for years at old-time square and round dances. Many of his songs are local traditions; others he learned from his father who brought them home from the lumber camps where he worked at the beginning of the twentieth century. "Babes in the Woods," "Memories of Home," and "Silver Stream Waltz" are some of the songs credited to Goog.

Goog has helped many people learn to play the fiddle, but he is especially credited with a lesson on keeping time when playing. "If you don't have timing, you have nothing," Goog often warns.[2]

One of his fellow fiddlers claims that Goog can "still crank out a jig or a reel or a waltz with the best of them and still keep the right timing."[3]

A fellow member of the Original Michigan Fiddlers Association stated that Goog "could play until the last dog dies, and then still have energy to play for the funeral. . . . If he ever stops playing his music, he will leave a big hole in a lot of peoples' hearts."[4]

1. Cited in Cynthia Glazer, "89-year-old musician not just fiddling around," *Pioneer News.* 19 June 1996.
2. Edward Deming. Letter of support for nomination of Goog Douglass. 7 January 2001.
3. Sandra Jones. Letter of support for nomination of Goog Douglass. 6 January 2001.
4. Deming, Edward. Letter of support for nomination of Goog Douglass. 7 January 2001.

Gertrude Kurath

POSTHUMOUS AWARDEE • ANN ARBOR / WASHTENAW COUNTY • DOCUMENTER OF WOODLAND INDIAN DANCE AND CULTURE;
FOUNDER OF THE DISCIPLINE OF DANCE ETHNOLOGY

Gertrude Kurath (1903–92) was a pioneer in dance ethnology whose groundbreaking contributions to Native American studies, anthropology, ethnomusicology, and dance enriched present and future native peoples as well as scholars.[1]

Her work with native peoples included studies of music and dance, based on fieldwork among the Iroquois in New York and Canada, the Central Algonquians (Odawa, Ojibwa, Potawatomi, Muskouten, Sauk, Fox, Menominee, and Miami) in the Great Lakes region, Pueblo villages in New Mexico, and in Mexico. Her documents contain detailed accounts of dance movements and examination of dance as an expression of culture. Her studies of native dance established what is known today as dance ethnology.

Gertrude's incredible work with Michigan's native cultures is made even more valuable by her carefully compiled records on music, ritual, and dance that span four decades (1940s–1980s). These records preserve the cultural context and explanations of events with the voices of many native elders, sounds, diagrams, and films. In addition to numerous books, articles, comments, and reviews, there are field notes, tapes of field music recordings, LP recordings, colored and black-and-white film, photographs, slides, musical and choreographic transcriptions, and texts in sung and spoken native languages with English translations. Among her contributions are the Ethnic Folkways recording *Songs and Dances*

Photo courtesy of Ellen Kurath.

of Great Lake Indians and the 1967 publication *Michigan Indian Festivals*, complete with photographs, diagrams, and musical transcriptions. A manuscript written with Jane and Fred Ettawageshik in the 1950s is being edited by Frank Ettawageshik for publication.

Throughout her career, Gertrude continued her commitment to careful research and shared her results in ways that would benefit the most people, especially her native collaborators. In her works, interested native peoples can find voices of identified knowledgeable elders as critical resources about their cultural heritage. Gertrude's contributions have led to new, richer ways of understanding art in culture. The disciplines of ethnomusicology, anthropology, dance, and folklore would be poorer without her accomplishments.

1. Information on Kurath is based on support letters from Charlotte Frisbie and Joann W. Kealiinohomoku. 2000.

Oren & Toni Tikkanen

CALUMET / HOUGHTON COUNTY • PROMOTERS, SUPPORTERS, AND
CHRONICLERS OF UPPER PENINSULA TRADITIONAL MUSIC AND DANCE

03-2002:26.3:6. Photo by Mary Whalen.

Toni (b. 1946) and Oren (b. 1943) Tikkanen are recognized by their fellow Yoopers (the term for residents of the Upper Peninsula) and Finnish Americans as true leaders and role models. They are dedicated promoters of traditional regional and ethnic music and dance in central Upper Peninsula. Through their unselfish support of traditional arts, the Tikkanens have strengthened local identity and pride and promoted understanding among diverse groups.

Although active with a range of regional groups and traditions, the Tikkanens' primary work is with Finnish Americans. Their list of accomplishments is commendable. By locating and restoring early 78 rpm recordings, they have been instrumental in preserving the music and song of the immigrant generation and introducing legendary artists and their music to today's Finnish Americans and to Finnish nationals in Finland. The Tikkanens also have produced cassette recordings of contemporary local musicians playing traditional music that has great meaning to Finnish Americans. Their efforts were rewarded when the American Folklife Center selected two of their recordings, first a reissue and then one of Oren's original productions, for the center's annual list of the best recordings of traditional music for their given year.

The Tikkanens augment their dedication to preservation as skilled performers. Often they play backup for older musicians who perform for local events and at annual folk music festivals. As an Upper Peninsula native son, Oren grew up in a context of multicultural music, jokes, stories, and dialect. Using this traditional repertoire, he developed his talents not only as a performer of traditional music but also as a raconteur and an engaging master of ceremonies able to present an extraordinary range of musicians and other performers.

Dr. James Leary of the University of Wisconsin, Madison, says about the Tikkanens "that [they] have done so much for so long for so many is indicative of both their love of Finnish American music and of their generosity. It is appropriate that the Michigan Traditional Arts Program publicly recognize Oren and Toni Tikkanen for the longevity and worth of their dedication. They are a cultural treasure.[1]

03-2002:26.7:13. Photo by Mary Whalen.

1. James Leary. Letter of support for nomination of Oren and Toni Tikkanen. 1 December 2000.

Glen VanAntwerp

TUSTIN / OSCEOLA COUNTY • CEDAR FAN CARVER

Photo by Mary Whalen.

Photo by Al Kamuda.

Cedar-fan carving is an old and widespread tradition of using only a simple knife and a single block of cedar wood to create delicate fans. Immigrants from northern Europe first brought the technique to Michigan and other parts of the United States. Some of these immigrants worked as lumberjacks, and it was in the lumber camps, during long winter nights of storytelling and whittling, that the art of fan carving spread and developed.

Glen VanAntwerp's connection with cedar fans begins with this lumber camp era. His great-great-grandfather settled in northern Michigan where, as a young man, he worked as a lumberjack. Later, Glen's grandfather, Elmer, was born in a lumber camp where his father was the foreman and his mother served as cook. As a young man, Elmer learned cedar fan carving from his relatives and other lumberjacks. He passed the skill on and Glen made his first cedar fan at the age of twelve in 1961, instructed by his grandfather, Elmer, and father, Stan.

About those early years Glen wrote, "Each piece of wood I worked with was a new mystery. Locked within it were the flaws, colors, and grain patterns that would determine the fan's final appearance. . . [and be a] discovery of the wood's hidden beauty."[1]

Now more than 40 years later he still derives great pleasure from his carving and has even developed some variations that the lumberjacks of long ago never dreamed of. Glen makes various types of small birds with outspread wings, fan-tailed peacocks and grouse, flying doves with fan-spread tails, and decorative fans with wooden handles.

Glen lives near Cadillac on property that has been his family's for a century. He gets his white cedar from his own land, using dead or fallen trees and saving living ones for future generations. Some of his favorite wood is old cedar fence post, well seasoned, straight-grained, and hard.

Glen has passed on his fascination for fan carving to his son, Jeremy, and his daughter, Sara, to whom he has taught both the stories and practice of cedar-fan carving. He also has taught numerous workshops around Michigan, demonstrating fan carving to neighbors, school children, and friends and educating them about the art nurtured in Michigan lumber camps. Glen has strengthened, preserved, and promoted this beautiful tradition by generating new interest in it through his instruction and demonstrations.

1. Glen VanAntwerp. "The Fan Man," *Eberly's Michigan Journal,* 1980.

MICHIGAN HERITAGE AWARDS 2002

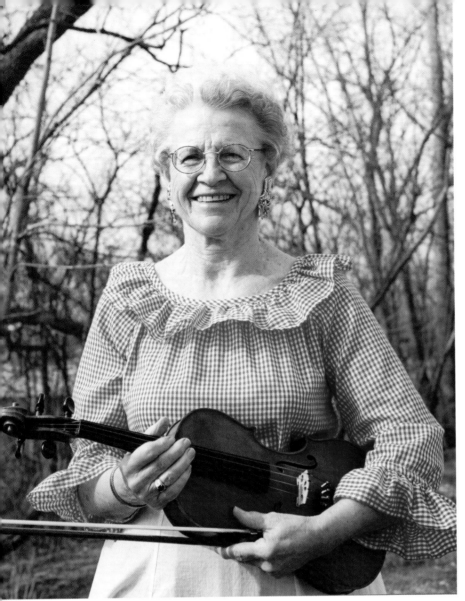

Lois Bettesworth

FLUSHING / GENESEE COUNTY • OLD-TIME FIDDLER

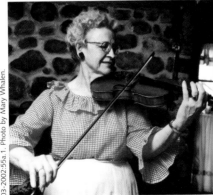

03-2002:55a.1. Photo by Mary Whalen.

1. Stephen Williams. Letter of nomination for Lois Bettesworth. 10 May 2001.

Lois Bettesworth was introduced to fiddling by her father, Burt Hutchinson, who used to play for house parties in Michigan. Born in Minnesota in 1925, Lois and her family moved to Michigan soon after. Lois attended her first house party at age one, began playing fiddle at age nine, and played twin fiddles together with her father for many years thereafter. Her formal music instruction with other teachers lasted for ten years. Steeped in the music tradition of her father and grandfather, however, her dedication to and perpetuation of the old-time Missouri fiddling style has not waned.

Accolades for Lois call attention to her musical ability, her generosity and encouragement to others, and her commitment to fiddling. Stephen Williams, fellow fiddler and director of the Port Huron Museum of Art and History, credits her with inspiring him to become a musician more than 25 years ago. "She showed me the rudiments of bowing and fingering and she gave me her own recordings of tunes played the way her father had played them. When she felt confident that I was serious about this venerable tradition, she handed me her father's instrument and charged me with the awesome responsibility of keeping both the tradition and the fiddle alive."[1]

Lois has played for dances through the years with a number of bands. In 1951 she organized her first dance band that played for square dances. She plays at various statewide fiddlers' jamborees, including the one she established in Flushing. In 1978 she organized an old-time band, Shades of Blue, for which she is the lead singer and fiddler. The band plays without a fee at senior centers, schools, churches, care homes, class reunions, round and square dances, community events, festivals, and jamborees in the region. In addition to her dedication to old-time music, Lois plays a key role in the Flushing Area Historical Society and is active in many ways in her community. She continues to have a profound influence on many individuals who all agree, "she is one of a kind."

Paul Lahti

03-2002:55b.1:26. Photo by Mary Whalen.

P aul Lahti learned the techniques and aesthetics of rag-rug weaving from his immigrant grandmother, who learned to weave in Finland, and his Finnish American mother. Locals praise his rugs for their tight weave, careful designs, and handsome colors. According to nominator and artist Joyce Kosenmaki, they "are cherished by their owners" and "have a spirit which graces the rooms in which they lie."[1]

Paul was born in the Upper Peninsula's L'Anse/Herman area in 1938, a time when every Finnish home used rag rugs and weaving was a skill in which many took pride. As a child he assisted the weavers in his family by repairing their looms and with preparing rags, warping looms, and tying fringes. He actually began to weave at age thirteen. As a young man, Paul, who had always been good at carpentry, established his own construction company. Despite his busy life, he always managed to find time to weave. When he retired, he opened a coffee and craft shop, in the backroom of which he set up a weaving studio where he wove on an old, immigrant-made loom and taught others to weave. He now was able to devote himself to weaving. The shop also served as an outlet for the traditional Finnish foods he enjoyed cooking. It became a gathering place for locals where they visited as they drank coffee and ate Finnish coffee bread. On Sundays, he served a special brunch of Finnish specialties. Although the shop is now closed, Paul is still weaving and aspires to making a loom.

Paul's dedication to the preservation of Finnish history and culture extended to the restoration of the Herman Community Hall built in 1901 by Finnish immigrants and for which he donated his time and carpentry skills. His selfless enthusiasm and volunteer efforts for his community include donations of his rag rugs for raffles and various local fundraisers. Paul's devotion to old Finnish traditions endears him to his neighbors and friends.

1. Joyce Koskenmaki. Letter of nomination for Paul Lahti. 27 November 2000.

Giovanni "Johnny" Battista Perona

CALUMET / HOUGHTON COUNTY • BONES PLAYER

03-2002:55c.2:27. Photo by Mary Whalen.

Giovanni Perona, known locally as "Johnny," has been a farmer, laborer, custodian, and always a musician. He is regarded as a virtuoso on the concertina, accordion, violin, mandolin, and guitar, instruments on which he has played old-time dance music for Italians, Finns, Slovenians, and Croatians at house parties and community dances for more than sixty years. According to Oren Tikkanen, he is considered "a one-man Yooper multi-ethnic festival."[1] (Yooper is the term for a resident of the Upper Peninsula). It is his mastery, repertoire, and performance style with bones and spoons, however, that is most widely appreciated. Musician Randy Seppala said of Johnny, "He just may be the greatest bones and spoons player in the country. He is certainly a great master, playing with an intensity and technical precision unequaled by anyone I am aware of."[2]

Johnny's preferred instruments are four rib-shaped bones crafted of smooth, curved ebony wood by a Finnish immigrant carpenter. His introduction to the bones began in 1948. Johnny was playing his concertina in a local tavern that a bones and spoon player often frequented, playing to the music of the jukebox for drinks. He also kept time to Johnny's music, using spoons. He showed Johnny how to hold the spoons, but fearing competition, he was not encouraging when Johnny found them awkward. At that time, Johnny happened to find a set of bones, and he also made a set from horse ribs. Thus Johnny began his love for the bones.

Although Italian-American, it is not surprising that in this densely Finnish American area of the Upper Peninsula Johnny is well acquainted with Finnish-American music. In the early 1980s he began playing traditional Finnish music with local Finnish American musicians. Consequently, in this region of the country, traditional Finnish American music includes bones and spoons. Johnny explains about himself, "Johnny's bones were made by a Finnish immigrant, so, although he has not Finnish blood in his veins, he does have Finnish bones in his hands."[3]

As a native and resident of the Keewenaw Peninsula, Johnny (b. 1920) also is a treasure trove of stories, ethnic jokes, knowledge about the history of the area and of butterflies. He has always been fascinated with butterflies, and since 1961 he has compiled a large scientific collection of *lepidoptera*. Whether it is music, butterflies, bugs, musical instrument refinishing projects, or gardening, Johnny continues as master of his lifelong interests.

1. Oren Tikkanen. Letter of support for nomination of Johnny Perona. 3 December 2001.
2. Randy Seppala. Letter of nomination for Johnny Perona. 1 December 2001.
3. Oren Tikkanen. "Johnny Perona. Butterflies & Bones." *Peninsula People* (September/October) 1991:12.

Adell Beatrice Raisanen

Adell Raisanen, known as Bea, is a master rag weaver in the Finnish American tradition. She was born in 1917 and grew up in a Finnish American community in Minnesota where rag rugs were used in homes and weaving was a skill brought by immigrants from Finland. Bea's mother taught her to weave, but like most women of her generation, it was many years before she returned to this tradition. In the interim, Bea moved to Detroit where she held several jobs, including a position in an aircraft factory during World War II, and she raised a family. In 1958 she purchased her first rug loom, and since then she has been recycling old clothes, blankets, sheets, towels, etc., into beautiful, highly coveted rugs for her home, gifts, and occasional sales.

Bea's technical perfection and use of breathtaking colors are the result of many decades of weaving. Fellow weaver Doris Allen refers to Bea's loom as "the canvas of a great artist .There is no suggestion of randomness in her choice of materials; everything is integrated into a complete picture."[1]

With her mother's instructions, occasional reference to books and other weavers, visits to Finland where rag weaving is also highly prized, and her husband, Arnold, who keeps her loom in top working order, Bea continues to excel in her art and to attract admiration and praise.

She has taught her weaving skills and techniques to apprentices through the Michigan Traditional Arts Apprenticeship Program (1994, 1996, 1998–2000), infecting her apprentices with the love of weaving and reinforcing the tradition in the greater Detroit area. Bea is an active member of FinnWeavers, a group affiliated with the Finnish Center Association in Farmington Hills. She has also displayed her work at the national FinnFest, demonstrated weaving at the National Folk Festival, and has received awards from the Michigan League of Handweavers and at the Michigan State Fair. Despite all the attention, Bea continues to give generously of her time to help weavers with their problems and to teach her "tricks of the trade."

03-2002:55d.1:14. Photo by Mary Whalen.

1. Doris V. Allen. Letter of nomination for Adell Beatrice Raisanen. November 2000.

Mary Schafer

Mary Schafer has long been recognized as one of the fore-runners in quilt studies as well as the developer of one of the most important quilt history collections in the United States. In addition to being well known for her exemplary quilting, Mary has been a staunch supporter of local history organizations, loaning her quilts for exhibitions and regularly donating quilts to raise funds through raffles and other fundraisers.

Mary was born on April 27, 1910 in Austria-Hungary and immigrated with her family first to Kansas City, Kansas, and then, in 1920, to Flint. Her mother passed away shortly after coming to Kansas City but other women in her neighborhood there and in Michigan nurtured Mary's early love of sewing, tatting, and other needlework. She made her first quilt in 1956, copying an old one she had found and repaired, and, in the process, became interested in quilting and quilt history.

During this period, published materials on quilting were scarce and often hard to find, but Mary diligently wrote others, joined "round robins," subscribed to ephemeral quilting magazines, and became one of the leaders in a network of individuals sharing information. Determined to share her newfound information about quilters with others "because I think that they should have more honor than they have for their work,"[1]

Mary gave her first public presentation in April 1971 at the YWCA and subsequently spoke to many groups, particularly in the Great Lakes region, on both historical and technical aspects of quilting. Simultaneously, she began entering her own quilts in juried quilt exhibitions, winning top prizes in local and national events for her classic quilts featuring original borders and quilting designs-elements that became Mary's trademark. By the time of the quilting revival of the 1970s, Mary had become a well-known figure in the quilting world.

Recently, individuals and groups across Michigan and the nation donated funds to help the MSU Museum acquired part of her collection—developed over a period of forty years—of more than 200 quilts plus quilt tops, fabrics, and quilt blocks representative of most quilt styles and periods in American history. This collection, now in public stewardship, will continue Mary's dream of celebrating quilters and educating the public about quilt history.

03-2002:55e.1:28. Photo by Mary Whalen.

1. Interview by Mary Worall. East Lansing, Michigan. 12 December 2001.

MICHIGAN HERITAGE AWARDS

2003

Richard M. Dorson

POSTHUMOUS AWARDEE • BLOOMINGTON, INDIANA • FOLKLIFE SCHOLAR AND EDUCATOR

Photo courtesy of Lilly Library, Indiana University, Bloomington, Indiana.

Courtesy of the Michigan Traditional Arts Program.

BLOOD-STOPPERS AND BEAR WALKERS

folk tales of Immigrants, Lumberjacks & Indians

Richard M. Dorson

Richard M. Dorson (1916–1981) was Distinguished Professor of History and Folklore and Director of the Folklore Institute at Indiana University. He was a remarkable and energetic scholar who, at the time of his death, was a dominant force in the study of folklore. Dr. Dorson's documentation of Upper Peninsula and southwestern Michigan traditions is his legacy to Michiganders.

In 1944 Richard Dorson joined the faculty at Michigan State College (now Michigan State University); in 1957 he left for Indiana University. During his time at Michigan State College, he and his students conducted groundbreaking research in Michigan, documenting everyday life and expression that have since changed or no longer exist. In 1946, Richard Dorson drove the byways of Michigan's Upper Peninsula, sat in hotel lobbies and homes, in barbershops and Grange Halls, in bars and church basements, collecting the oral traditions, customs, and beliefs of the region's diverse population. The Upper Peninsula for Richard Dorson was a microcosm of America. In this thinking, he was well ahead of his time. Here he found different ethnicities, languages, religions, and occupations. It was a region where history, environment, economy, politics, and diverse peoples forged the region's folklore within the trajectory of American history.

Dorson's research in the Upper Peninsula left a rich record of folklife of a specific region at a specific moment in American history, resulting in a number of articles and *Bloodstoppers and Bearwalkers* which has been reprinted many times since it was first published in 1952.[1]

Dr. Dorson also conducted important work among African Americans of southwestern Michigan. His research resulted in historically and culturally important records, published in articles and books, including *Negro Folktales in Michigan*[2] and *Negro Tales from Pine Bluff, Arkansas, and Calvin, Michigan*.[3]

He also documented the folklore of Michigan State College students, questioning the popular assumptions about who are the folk and proving that students and educated classes are also the folk.

Our understanding of American folklore and the cultural history of the Upper Peninsula would be poorer without Richard Dorson's work. His popular writings forced students and scholars of culture to look closely at Michigan's cultural inheritance and relate it to their own experience. He brought attention to a region, culture, and people who eluded national attention.

1. Richard M. Dorson. *Bloodstoppers and Bearwalkers*. Cambridge: Harvard University Press, 1952.
2. Richard M. Dorson. *Negro Folktales in Michigan*. Cambridge: Harvard University Press, 1956. Reprinted 1974, Greenwood Press, Westport, Connecticut.
3. Richard M. Dorson. *Negro Folktales from Pine Bluff, Arkansas and Calvin, Michigan*. Bloomington: Indiana University Press, 1958.

Laina Marie Lampi

CLAWSON / MACOMB COUNTY • FINNISH-AMERICAN RAG RUG WEAVER

Laina (Kehus) Lampi (b. 1914) is an exceptional rag rug weaver in the Finnish-American tradition. As a child growing up in Tapiola, she learned about weaving from her mother, who had learned in Finland; however, it would be many years before Laina began to weave on a regular basis. Like many young females of her generation who left home to seek work in big cities in the 1930s, Laina went to Detroit, where she found employment. Eventually she married and raised a family. Upon her mother's death, she received her mother's precious loom, large, old and immigrant-made, which Laina values highly and on which she has been weaving for over forty years. She credits her loom for her ability to make pleasing rugs. "A good rug," she often states, "requires a good loom."[1]

Laina's technical perfection and expert use of colors are also the result of decades of weaving. Like all Finnish-American weavers, she is a consummate recycler. Her rags come from old clothing, blankets, sheets, and towels people give her or she finds at flea markets, rummage sales, and resale shops. Recycling these discards into beautiful rugs is her special art. It also is her way "to save the earth." Color is one of the standards she looks for in rugs and her own sense of color is exceptional. Doris Allen, weaver and fellow member of FinnWeavers (Farmington Hills, Michigan), lauds Laina's artistry, "The technical construction [as seen in Laina's rugs] can be achieved by others, if they work at it, but the colors and designs are from an artistic soul . . . Laina has managed to raise the production of rag rugs, conventionally thought of as a utilitarian form, to an art form."[2]

Photos by Mary Whalen.

As a preservationist and proud Finnish American, Laina has consciously taught her skills and knowledge perfected over the years to others in her family who share her enthusiasm and has mentored many beginning rag rug weavers. She has displayed her rugs at FinnFest and in the traveling exhibition *A Living Legacy: Finnish American Rag Rugs,* and has made a number of presentations about rag-rug weaving to other weavers' guilds. "My weaving life," Laina said, "has been very fulfilling."[3]

1. Personal communication with Yvonne Lockwood, 1991.
2. Doris V. Allen. Letter of nomination for Laina Lampi. November 2002.
3. Ibid.

Ronald J. Paquin

SAULT STE. MARIE / CHIPPEWA COUNTY • BIRCH BARK CANOE MAKER

Ronald J. Paquin (b. 1942) is a proud member of the Sault Ste. Marie Tribe of Chippewa Indians. Although only in his 50s, he is known as a traditionalist and preserver of traditional skills and he believes he has a responsibility to teach others of his tribe about their heritage. He has devoted himself to teaching family and community members a variety of Ojibwa traditions. Ron makes birch bark containers, antler and bone carvings, knives, cedar and deer hide drums, porcupine quill boxes, beadwork, black ash baskets, fishing nets, and birch bark canoes. He is a storyteller and a fisherman. Although a master of these Ojibwa traditions, Ron is being recognized for maintaining and reinforcing the tradition of birch bark canoe making.

Canoes are important to Ojibwa culture and history and Ron is committed to their perpetuation. Years ago, when Ron first realized he wanted to make canoes, his uncle deemed it impractical for him to make them because "tourists weren't interested in buying them."[1]

However, as he watched the masters of this craft die, Ron knew if he didn't learn, there wouldn't be anyone left to teach subsequent generations. He worked with family and tribal members to learn carpentry skills and the gathering and processing of materials, and he talked with elders to "learn bits and pieces." He also studied older canoes and occasionally he turned to books. By 2003 he had made some twelve canoes, about one a year. One canoe was completed with a master artist grant from ArtServe Michigan; another was made with support from the Michigan Traditional Arts Apprenticeship Program. Ron often involves community youth and adults in his canoe-making projects; males do the actual building and women do the sewing. He has also made canoes in schools with students. Many of his canoes go to tribal collections in museums in Michigan.

Ron has helped many people in his area gain an appreciation of Native culture through projects at the Museum of Ojibwa Culture in St. Ignace, Michigan, through the tribe, with his activities with students, and by encouraging other elders to share their skills with young people. His mastery of canoe making is symbolic of his commitment to his heritage.

Photos by Mary Whalen.

1. Personal communication with Yvonne Lockwood, November 2002.

MICHIGAN HERITAGE AWARDS 2004

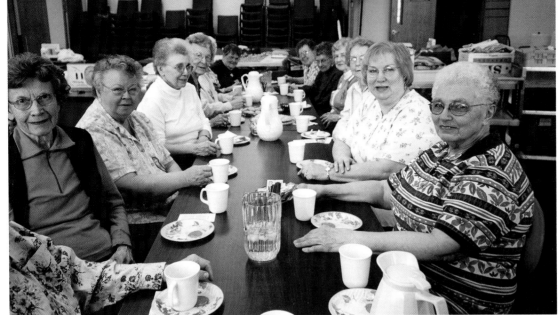

Photos by Chris Saari.

Messiah Quilters

MARQUETTE / MARQUETTE COUNTY • QUILTERS

In the late 1960s a small group of Marquette women came together to make quilts for the needy. Initially, they made about 25 a year. Today the Messiah Quilters ship about 700 quilts a year by boxcar to the Lutheran World Relief distribution center and make a number of quilts for local organizations, charities, and fundraisers.[1] As of October 2003, according to quilter Natalie Maki, they had completed 11,233 quilts.[2]

Every Thursday sixteen to twenty-four individuals, mostly women and some men, meet in Magnuson Hall at the Messiah Lutheran Church. Some participate only in the morning or the afternoon but many stay the entire day. Other members of the group work out of their homes. Each focuses on a specific part of the process: preparing fabric for use; cutting, laying out, or sewing squares; preparing the lining and the back; tying the quilt together; binding edges. More than half the fabric used in the quilt top is recycled cloth; quilts also are often lined and backed with old blankets, flannel sheets, and other large pieces of recycled fabric. The recycled cloth is acquired by donations from members and the community at large or purchased with monetary donations. When cleaning closets or downsizing, for example, local residents bring discarded clothing, sheets, and drapes. Other quilters, who have accumulated more material than they will ever use, donate part of their treasured fabric stash. Messiah Quilters purchase new fabric on-sale and used clothing and fabrics by the bagful at St. Vincent DePaul and at 50 percent off at the Goodwill Industries.

The choice of available materials, timeline, and destination of the quilt are factors that determine its appearance and thickness. When it is known that the quilts will be used on the ground, the first concern is to make a sturdy, warm covering. When the quilts are made for a silent auction to raise money, however, the quilts tend to be larger and from new fabrics.

Making quilts is a work of generosity and goodwill for the Messiah Quilters. It also is a social time where they exchange news and develop friendships. Each afternoon, the quilters take time for coffee and food they bring from their kitchens. The Messiah Quilters are recognized with a 2004 Michigan Heritage Award for their decades of quilt making to help the needy.

1. *Marquette Monthly.* November 1999. p. 17
2. Personal communication with Yvonne Lockwood. March 2004.

James Rice

HUDSON / LENAWEE COUNTY • SADDLEMAKER AND LEATHER WORKER

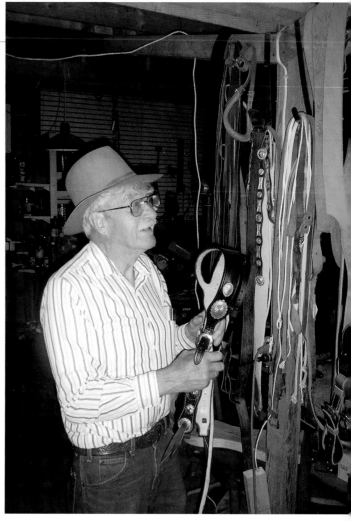

James Rice (b. 1928) grew up helping repair saddles for his horse-trading uncle. "I could fix what some of the outlaw horses tore up," he boasted. By the age of 16 he had built his first saddle and eventually learned the saddle-making trade from Billy Ecker, a craftsman for the Henry Kellogg buggy and harness shop in Hudson. Decades later, he has his own shop and is still putting his "Jas. Rice" stamp on saddles prized across America for their beauty and durability. Along the way, he has also been a rodeo broncobuster, metal shop class instructor for seventh through ninth graders, singer, barber, and farmer of 76 acres.

"The prime key to being a good saddle maker," says Jim, "is fitting the horse first."[1]

Jim's saddles begin with wooden frame, called a "tree," made to fit the horse's shape and the rider's weight. The various steps include cutting and stitching together skirting leather and engraving and tooling designs on the leather. The saddles are his design, heavily engraved with intricate shapes and custom designs that he does completely by hand. "I like to put quite a lot of stamping on," said Jim, "I guess my saddles are known for large skirts."[2]

Jim fills orders for his handsome saddles from around the country. Some of the more unusual orders he has filled included saddles with a motorcycle and another with nudes. One special order was for a miniature saddle for a monkey that was to ride a small horse. Another one for the

Photos by Mary Whalen.

Lenawee County sheriff featured white pine branches and cones, white tail deer, robins, and apple blossoms. He is especially proud, however, of saddles made for a club in Alaska depicting bears and moose.[3]

Jim makes saddles for hardworking ranchers and for pleasure riders, who tend to prefer silver-studded show saddles; he has also made a saddle for President George W. Bush. Jim also repairs and restores old saddles and makes belts and gun holsters.

During his 50 plus years of saddle making, Jim has taught several others and he is the recipient of a Michigan Traditional Arts Apprenticeship Award. His most recent apprentice, Danielle Cole, has been working with Jim for several years. Enthusiastic about her work, Jim is grooming Danielle to take over the business.

1. *Bi-County Herald,* December 5, 2001.
2. *The Daily Telegram,* February 17, 2002.
3. Interview by William G. Lockwood. May 2004.

Stás Wiśniach

FARMINGTON / OAKLAND COUNTY • ACCORDIONIST AND MASTER OF POLISH FOLK MUSIC

Photos by Mary Whalen.

Stás Wisniach (b. 1923) is an outstanding master accordionist and a symbol of Polish traditional music. He began accordion lessons at about the age of 4 when his parents recognized his musical potential after hearing him play an accordion given to him by his uncle. His father once took him to a wedding, accordion in tow, and sat him beside a concertina player. Stás played along in perfect time, and it was then that his father invested in a larger accordion.

When Stás was 9, he organized his own band and played at neighborhood clubs, dances, and many different Polish social events. In 1945 he graduated from the Detroit Institute of Musical Art as the first student with a major in the accordion. In the 1950s he became the orchestra leader of the *Club Polka* show on WXYZ and also performed on *Soupy Sales* and *Our Friend Harry*. He moved to California in 1966 where he lived and performed professionally for Polish communities and others. He returned to Detroit in 2001 to perform at the gala reception of the exhibition, "Polish Presence in Detroit," at the Detroit Historical Museum, and he has remained.

During his more-than-seventy-year career, Stás has taught accordion to many. He also has made a number of recordings. It is, however, the 1960s collection of Polish folk ballads, "Sentimental Journey to Poland," with the Jan Wojnar ensemble that Polish music historian Laurie Gomulka Palazzolo regards as "one of the most perfect recordings ever made." She states, "Stás's work on this recording represents some of the finest musicianship I have ever heard"[1]

Stás continues to perform and teach, and he has a large following in southeast Michigan and widespread recognition of a lifetime dedicated to the accordion and maintenance of Polis traditional music. In 2004 he was selected for a Michigan Traditional Arts Apprenticeship award to teach accordion and Polish music to Georgiana Leonard.

1. Laurie Gomulka Palazzolo. Letter of nomination for Stás Wisniach. December 2003.

Selected Bibliography[*]

Interviews Cited

Angman, Ellen. Interview by Yvonne R. Lock-
wood and Martha Brownscombe. 1986.

Armstrong, Howard. Interview by Laurie K.
Sommers.

Baganz, Edward C. Interview by LuAnne Kozma,
Harsens Island, Michigan. 1985.

Clark, Mattie Moss. Interview by Deborah Smith
Pollard, Detroit, Michigan. 1990.

Crampton, Anna. Interview by Betsy Adler at the
Great Lakes Indian Basket and Boxmakers
Gathering, East Lansing, Michigan. 1997.

Dlaikan, Nadim. Field report by Sarah F. Howell,
Southgate, Michigan. 1994.

Engelhard, Henry. Interview by LuAnne Kozma,
Bayport, Michigan, 1995; Interview by
Yvonne Lockwood with 4-H team, 1996.

Esch, Donna. Interview by C. Kurt Dewhurst.
1986.

Gillespie, Jewell Francis. Interview by Laurie K.
Sommers, Beaver Island, Michigan. 1990.
Green, Deonna. Interview by Marsha Mac-
Dowell, Remus, Michigan. 1991.

Hagemeister, Paul. Interview by Julie Avery and
Steve Stier.

Lassila, Anna. Interviews by Yvonne Lockwood
and Martha Brownscombe. 1986-1989.

Likely, Deacon Albert. Interviews by Deborah
Smith Pollard, Detroit, Michigan.1983; 1989.

McCoy, Lawrence. Interview by Roger Pilon,
Sugar Island, Michigan. 1985.

Mainer, Wade and Julia Mainer. Interview by
Laurie K. Sommers. 1989.

Perez, Sonia Maria. Interview by Laurie K.
Sommers. 1988.

Raber, Les. Interview by Laurie K. Sommers.
1989.

Raisanen, Beatrice. Interview by Yvonne Lock-
wood. 1993.

Rapelje, Daniel. Interview by LuAnne Kozma.
1987.

Rapp, Agnes. Interview by Laura Quackenbush at
the Great Lakes Indian Basket and Boxmak-
ers Gathering, East Lansing, Michigan. 1997.

Schafer, Mary. Interview by Mary Worrall, East
Lansing, Michigan. 2001.

Stephan, Jay. Interview by C. Kurt Dewhurst and
Marsha MacDowell, Grayling, Michigan.
1986.Stevens, Don. Interview by Lynne
Swanson, East Lansing, Michigan. 1991.

Stevens, William. Interview by Laurie K. Som-
mers. 1989.

Stewart, Elman. Interview by C. Kurt Dewhurst
and Marsha MacDowell, Alpena, Michigan.
1985.

Thomas, Eli. Interview by Patricia Dyer, Mt.
Pleasant, Michigan. 1988.

Vuorenmaa, Irene. Interview by Yvonne R. Lock-
wood and Martha Brownscombe. 1988.

*Please note that, in addition to the cited source material, field notes from Michigan Traditional Arts Program projects, as well as the
Michigan Traditional Arts Apprenticeship Program and Michigan Heritage Awards Program files, were utilized in constructing the
descriptions of each awardee.

Wenson, Fritz. Interview by LuAnne G. Kozma, Farmington Hills, Michigan. 1995.

Williams, Lula. Interview by Marsha MacDowell, Detroit, Michigan. 1996.

Unpublished Materials Cited

Agrawal, Aparna. Letter of nomination for Pushpa Jain. 1993.

Allen, Doris V. Letter of support for nomination of Adele Raisanen. 2000.

Allen, Doris V. Nomination for Laina Lampi. 2002.

Carter, Todd. Untitled. Student research paper. 1985.

Cicala, John Allan. 1987 Festival of American Folklife field report. 1986.

Clark, Donna. "Duck Decoy Carving," Student paper. 1979.

Deming, Edward. Letter of support for nomination of Goog Douglas. 2001.

Haycock, Naomi. Letter of nomination for Lois LaFernier. 1997.

Howell, Sally. Nomination of Nadim Dlaikan. 1993.

Jones, Sandra. Letter of nomination for Goog Douglas. 2001.

Kangas, Melvin. Michigan Traditional Arts Apprenticeship Program file materials. 1999.

Koskenmaki, Joyce. Nomination of Paul Lahti. 2000.

Kostecki, Mary. Nomination of Mary Torsky. 1999.

Krysa, Czeslaw. Michigan Traditional Arts Apprenticeship Program file materials. 1993.

Leary, James. Letter of support for nomination of Oren and Toni Tikkanen. 2000.

Lumsden, Joseph. Letter of nomination for Harriet Shedawin. 1986.

MacDowell, Marsha. Field notes. 1980.

Olson, Ruth. Nomination of Irene Vuorenmaa. 1999.

Seppala, Randy. Nomination for Johnny Perona. 2001.

Spitzer, Nick. 1987 Festival of American Folklife field report. 1986.

Tipton, Susan. Letter of support for nomination of Czeslaw Krysa. 1992

Williams, Stephen. Letter of nomination for Lois Bettesworth. 2001.

Published Work Cited

———. "1998 Michigan Heritage Award Winners," in Yvonne Lockwood and Marsha MacDowell, eds. *1998 Michigan Folklife Annual.* East Lansing: Michigan State University Museum, 1998.

———. "Little Sonny Willis," *Global Sounds Artists.* Minneapolis: Arts Midwest. 2001

———. "Finding Our Way Home: The Great Lakes Woodland People." *The Indiana Historian* (Special Issue), September 2001.

———. Obituary for Margarette Ernst. *St. Johns Reminder.* 25 June 1991.

Alexis, Philip and Barbara Paxson. *Potawatomi Indian Black Ash Basketry.* Dowagiac, Michigan: Pokagon Potawatomi Tribe, 1984.

Beck, Earl Clifton. *It Was This Way.* Ann Arbor: Cushing-Malloy, Inc., 1963.

Beck, Earl Clifton. *Songs of Michigan Lumberjacks.* Ann Arbor: University of Michigan Press, 1942.

Clifton, James A., George L. Cornell, James M. McClurken. *People of the Three Fires.* Grand Rapids: The Grand Rapids Inter-Tribal Council, 1986.

Colby, Joy Hakanson. "Louie Bluie," *The Detroit News,* 23 August 1990.

Conrad, Brenda. *Ionia Standard,* 3 February 1988.

Cristonomo, Manny. "The Fiddler," *The Detroit Free Press,* 23 May 1986.

Dewhurst, C. Kurt and Yvonne R. Lockwood, eds. *Michigan Folklife Reader*. East Lansing: Michigan State University Press, 1988.

Dorson, Richard. *Bloodstoppers and Bearwalkers*. Cambridge: Harvard University Press, 1952.

Dorson, Richard. *Negro Folktales in Michigan*. Cambridge: Harvard University Press, 1956. Reprinted 1974, Greenwood Press, Westport, Connecticut.

Dorson, Richard. *Negro Folktales from Pine Bluff, Arkansas and Calvin, Michigan*. Bloomington: Indiana University Press, 1958.

Glazer, Cynthia. "89-year-old musician not just fiddling around," *Pioneer News*. 19 June 1996.

Kamuda, Alan R. *Hands Across Michigan: Tradition Bearers*. Detroit, Michigan: *The Detroit Free Press*, 1993.

Kamuda, Alan R. "The Doctor Is In." *The Detroit Free Press*. 7 October 1987.

Kamuda, Alan R. "Retirement duck soup for UP decoy carver," *The Detroit Free Press*, n.d.

Kober, Dave. "Dave Kober Decoys," *http://www.koberdecoys.com/koberfamily.html*. 30 June 2002.

Kohn, Rita and W. Lynwood Montell. *Always a People: Oral Histories of Contemporary Woodland Indians*. Bloomington: Indiana University Press, 1996.

Kurath, Gertrude. *Michigan Indian Festivals*. 1967.

Langlois, Janet. "Feather Bowling and Floor Bowling in Detroit's Belgian Community," *1988 Festival of Michigan Folklife* (1988), pp. 19–22.

Langlois, Janet, "Thelma Grey James (1899–1988)," in Jan Harold Brunvand, ed. *American Folklore: An Encyclopedia*. Camden: Garland, 1996.

Leary, James. "Reading the 'Newspaper Dress': An Exposé of Art Moilanen's Musical Traditions," in C. Kurt Dewhurst and Yvonne Lockwood, eds. *Michigan Folklife Reader*. East Lansing: Michigan State University Press, 1988.

Loukinen, Michael. *Finnish American Lives*. VHS, 57 min. Up North Films, 1982.

Loukinen, Michael. *Good Man of the Woods*. VHS, 90 min. Up North Films, 1987.

Loukinen, Michael. *Tradition Bearers*. VHS, 47 min. Up North Films, 1983.

MacDowell, Marsha, ed. *Gatherings: Great Lakes Native Basket and Box Makers*. East Lansing: Michigan State University Museum with Nokomis Learning Center, 1999.

MacDowell, Marsha, ed. *African American Quiltmaking Traditions in Michigan*. East Lansing: Michigan State University Press in collaboration with Michigan State University Museum, 1998.

MacDowell, Marsha and Jan Reed, eds. *Sisters of the Great Lakes: Art of American Indian Women*. East Lansing: Michigan State University Museum with the Nokomis American Indian Learning Center, 1995.

MacDowell, Marsha. *Anishnaabek: Traditional Artists of Little Traverse Bay*. East Lansing: Michigan State University Museum with the Little Traverse Bay Bands of Odawa, 1996.

McDonald, Willy. "How to Carve a Hunting Decoy," *http://theduckblind.com/cyberclassroom/huntingdecoyarticle1.htm*. 15 May 2002.

McEwen, George. "Ivan Walton, A Pioneer Folklorist." *The Michigan Academician* (1970): 73–77.

Peterson, Kenneth L. "Bud Stewart: Michigan's Legendary Baitmaker," *Michigan Sportsman*, Vol. 10, No. 3 (April), 1985.

Sommers, Laurie K. *Beaver Island House Party*. East Lansing: Michigan State University Press, 1996.

Thomas, Floyd. "This Piping School Is No Pipe," *Detroit Times*. n.d.

Tikkanen, Oren. "Johnny Perona. Butterflies & Bones." *Peninsula People*, (September/October) 1991:12.

Vachon, Jingo Viitala. "Tall Timber Tales."

L'Anse, Michigan: *L'Anse Sentinel*, 1975.

Vachon, Jingo Viitala. "Sagas from Sisula." L'Anse, Michigan: *L'Anse Sentinel*, 1975.

Vachon, Jingo Viitala. "Finnish Fibbles." L'Anse, Michigan: *L'Anse Sentinel*, 1979.

VanAntwerp, Glen. "The Fan Man," *Eberly's Michigan Journal*, 1980.

Walton, Ivan with Joe Grimm. *Windjammers: Songs of the Great Lakes Sailors*. Detroit: Wayne State University Press, 2002

Wicks, Jim. "Decoy Delight," *Michigan Natural Resources Magazine*, (January–February) 1986:36–44.

Wicks, Jim and Marge Wicks. "Meet the Carvers," *http://www.southlakedecoys.com/html/meet.html*, 2002.

Williams, Stephen R., ed. *House Party: Reminiscences by Traditional Musician and Square Dance Callers in Michigan's Thumb Area.* Port Huron, Michigan: Museum of Arts and History, 1982.